✓Komar, Vitali & Aleksandr Melamid. **Komar/Melamid: two Soviet dissident artists.**

Southern Illinois Univ. Pr. Apr. 1979. 59p. ed. by Melvyn B. Nathanson. intro. by Jack Burnham. illus. LC 78-14254. ISBN 0-8093-0887-8. $15.                                     INT AFFAIRS/ART

The artists, who work as a team, received a fair amount of critical attention in the United States while they were still in the Soviet Union (they both emigrated to Israel in 1977). This is the first book to be published about them, covering the period 1972–1977. Komar/Melamid's art is an amusing and intelligent commentary on both Communist and capitalist trends: the USSR's excess of propaganda, the rampant consumerism in the West. The artists are the proponents of, among other things, a style they call "Sots"— Soviet pop art. The long essays that begin the book may help to make clear to Westerners why their art, which seems far from outré to us, is considered so subversive in their native land. An enlightening and entertaining study.—*Carol Rasmussen, "Library Journal"*

This is an uncorrected proof of a review scheduled for Library Journal, Apr. 15, 1979

Komar /     Melamid:

# Two Soviet Dissident Artists

**Edited by Melvyn B. Nathanson**
**With an Introduction by Jack Burnham**

*Southern Illinois University Press*
*Carbondale and Edwardsville*
*Feffer & Simons, Inc.*
*London and Amsterdam*

Library of Congress Cataloging in Publication Data

Komar, Vitali.
    Komar/Melamid, two Soviet dissident artists.

    Bibliography: p.
    1. Komar, Vitali.   2. Melamid, Aleksandr.   3. Dis-
sident art—Russia.   I. Melamid, Aleksandr, joint
author.   II. Nathanson, Melvyn B., 1944–   III. Title.
ND699.K557A4   1979        759.7        78-14254
ISBN 0-8093-0887-8

Designed by George Lenox

# Contents

List of Illustrations        vii

Komar/Melamid: Distortion of Soviet Reality
   By Melvyn B. Nathanson        ix

Paradox and Politics: The Art of Komar and Melamid
   By Jack Burnham        xv

Komar/Melamid: Soviet Dissident Art        1

The Temple of Komar and Melamid        53

# List of Illustrations

*Quotation*   2
*Laika Cigarette Box*   3
*Meeting between Solzhenitsyn and Böll at
   Rostropovich's Country House*   4
*Don't Babble*   5
*Double Self-Portrait*   6
*Post Art No. 1*   7
*Post Art No. 2*   8
*Post Art No. 3*   9
*History of Russia, no. 1*   10
*History of Russia, no. 4*   10
*History of Russia, no. 5*   11
*History of Russia, no. 6*   11
*N. Buchumov*   13
*N. Buchumov*   13
*Biography*   14
*Biography, detail a*   14
*Biography, detail b*   15
*Biography, detail c*   15
*Biography, detail d*   16
*Biography, detail e*   16
*Color Writing: Ideological Asbtraction,
   No. 1*   17
*Documents*   18
*Documents*   19
*Documents*   20
*Documents*   21
*Circle, Square, Triangle: Artists' Instructions*
   22
*Circle, Square, Triangle*   23
*Color Is a Mighty Power*   24
*Glory to Labor*   25
*Scenes from the Future* (Guggenheim Museum)
   26
*Scenes from the Future* (Kennedy Airport)   27
*Drawings from the Front*   28
*Drawings from the Front*   28
*Drawings from the Front*   28
*Factory for the Production of Blue Smoke*   29
*Questions New York Moscow New York
   Moscow*   30
*Scroll*   31
*History of the USSR, panels 46–50*   32
*History of the USSR, panels 51–55*   33

*History of the USSR, panels 56–58*   34
*Cut-Off Corner Series, Chemical Reaction*   35
*Cut-Off Corner Series, Not Yet Too Late*   36
*Cut-Off Corner Series, KGB*   37
*Cut-Off Corner Series, Reproduction from a
   Picture on a Subject from Russian History*
   38
*Prophet Obadiah*   39
Installation, Ronald Feldman Gallery, May 1977
   (*Farewell to Russia*)   40
*A Catalog of Superobjects—Supercomfort for
   Superpeople*   43
*A Catalog of Superobjects*   45
*A Catalog of Superobjects*   47
*A Catalog of Superobjects*   49
*Young Marx*   50
Installation, Ronald Feldman Gallery, May 1977
   (*Catalog of Superobjects* and *TransState*)
   51
*Passport* from *TransState*   52
*The Temple of Komar and Melamid*   53

Melvyn B. Nathanson

# Komar/Melamid: Distortion of Soviet Reality

Tuesday nights the Melamids were at home. Friends would come with food, wine, vodka, and eat, drink, and talk until early in the morning. The guests were young, bright, alert, part of Moscow's "liberal intelligentsia" of writers, artists, and scientists. It was a pleasure to be with them. Sometimes from the American embassy I could bring an occasional treat: a can of Campbell's tomato soup or a box of Brillo, images my friends knew well from their Warhol incarnation but had never actually seen, or even a bottle of Stolichnaya vodka, the best Soviet vodka, sold abroad for hard currency and no longer available in Moscow for rubles.

I spent the academic year 1972–73 studying mathematics at Moscow State University under the auspices of the US-USSR Cultural Exchange Program (IREX). I proved theorems in algebra and number theory, nothing of military importance, but the Russians are paranoid about foreigners. At various times they bugged my room, interrogated my friends, followed me through the streets. One quickly grows cautious, and accustomed to the tension. For an American alone in Moscow, the evenings with Aleksandr Melamid, his wife Katya, and their friends were a delight, an opportunity to relax, to dance, and discuss. The tension never disappeared completely. Always there were wry glances at the electric light fixtures or the telephone, as if to say: Suppose someone's listening. But to what? Dancing to rock music. Toasts over Georgian wine and vodka. Arguments about politics and romance. When one had to discuss a delicate subject, there were the usual rituals: a long walk outside in the snow, or notes passed quickly back and forth, read, and then immediately burned.

Aleksandr Melamid and his friend Vitali Komar were artists: a two-man collective to produce works in the style they called "Sots" art, for Socialist art, their Soviet version of Pop art. In the West, they would say repeatedly, there is an overproduction of things, of consumer goods. Pop art makes fun of this. But in the Soviet Union there are shortages of everything: of meat, clothes, cars, apartments. There is overproduction only of ideology. Political slogans, painted large, are everywhere, on billboards, in the streets, on the roofs of buildings: "Fulfill the plan." "Onward to the victory of communism." "Lenin lived, Lenin lives, Lenin will live." Heroic portraits and sculptures of Lenin abound. Komar/Melamid would satirize this style.

My friend Goldfarb had introduced me to Melamid. Aleksandr Melamid and Aleksandr Goldfarb are second cousins. They had grown up across the street from each other in an attractive neighborhood of Moscow, near the Soviet Academy of Sciences. Like many young Moscow dissidents, they lived in comfortable homes. Goldfarb's father is a distinguished professor of biochemistry; Melamid's is a senior specialist in German affairs in the Soviet Foreign Ministry. Goldfarb told me about his artist cousin and his collaborator Komar. Did I want to meet them? Absolutely. With other friends I had been visiting the studios of various unofficial Moscow artists. I would be happy to see two more.

Their studio was a small room in a large apartment, and Komar and Melamid were waiting, nervously, to display their work to an American for the first time. Some early paintings were in the studio. Melamid's self-portrait, a thin torso naked from the waist up, melancholy and pessimistic. Romantic night scenes of Moscow: a dark building with brightly lighted windows, yellow rectangles on a black field, with a staircase drawn outside the building. Komar and Melamid explained their new work, Sots art. Melamid got the idea while he was painting a portrait of Lenin on a billboard at a children's camp. Instead of Lenin, but in the same mosaic, heroic style that in the Soviet Union is used only to paint Lenin, he would paint the Jewish face of his father. This was the first painting in the series of works they called Sots art, their parody of Soviet propaganda overproduction. One after the other, Komar and Melamid held up their paintings. They declared themselves

a team, sharing ideas and sharing the execution of the ideas, but each held up the paintings that he himself had painted. My impression was that Melamid was the more clever and the more articulate, but that Komar was the better painter. Some of the paintings were on canvas, but most were on cardboard. The canvas paintings were eventually smuggled to New York; the cardboard paintings remain in Moscow. Komar and Melamid were eager, even then, that their work be known abroad. The light in the apartment was poor, and I had no flash for my camera, but propping up paintings on the windowsill, I photographed as well as I was able in the afternoon light. The red arrow rising toward the sun, graphing the increase in the production of pork. A dove and a sausage on the two ends of a balance: sausage outweighing dove. Instead of a sun, the hammer and sickle setting over the ocean. Instead of a Campbell's soup can, a reproduction of a package of Soviet cigarettes: *Laika*, named after the dog shot into space by the Soviet Union. *Quotation*: a large, rectangular array of little white squares on a red background. Americans might not understand, but Russians who see this painting break out laughing. Everywhere in Moscow, on walls, roofs, billboards, buses, are quotations from Marx, Engels, and Lenin, white letters on a red background, so many, so frequent, that one ceases to read them, ceases to realize that they are messages, but regards them as abstract forms, rows of white squares on a red field. There are two versions of this painting. I saw the first in Moscow in 1972. In the second, exhibited in New York in 1976, Komar and Melamid added quotation marks at the beginning of the first row and at the end of the last, to make the meaning of the painting clear.

In the spring of 1973, Komar and Melamid managed to find a room in an empty apartment in Moscow, a remarkable feat since the housing shortage is severe, and they turned the room into an environmental work called *Paradise*. The walls, floor, and ceiling were painted and covered with sculpted figures and bizarre electrical light effects. Soviet radio played in the background. A river of blue cloth flowed under a wooden bridge, while a hideous Stalin-like figure sculpted in a corner of the ceiling dripped blood, and a gold Buddha along the wall was covered with licelike miniature soldiers, planes, and tanks. To experience the work, one was thrust into the room alone and locked inside. Melamid broke his elbow while preparing *Paradise*, when the chair on which he stood to paint the ceiling collapsed.

Soviet artists suffer for not working in the officially approved styles. In December 1972, Komar and Melamid were expelled from the youth commission of the Union of Artists "for distortion of Soviet reality and nonconformity with the principles of Socialist realism."

I left Russia in June 1973. At Southern Illinois University in 1973–74 and at the Institute for Advanced Study in 1974–75, I continued to correspond with Komar and Melamid. They were cut off from information about the contemporary art world, and I would mail them art books and art magazines. Meanwhile, Goldfarb had turned political, becoming active in both the human rights and Jewish emigration movements, and through him many American newspaper correspondents in Moscow were introduced to Komar/Melamid. In March 1974, Hedrick Smith wrote a feature story about them in the *New York Times*, and a few months later Herbert Gold discussed them in *Playboy*. On 15 September 1974, three Moscow artists, Oscar Rabin, Vladimir Nemukhin, and Lydia Masterkova, organized an outdoor show of unofficial art. In full view of the foreign press and of foreign diplomats, Soviet policemen and vigilantes broke up the show with bulldozers and fire hoses, destroying many paintings and making headlines around the world. Instead of eliminating underground art, the Soviet government action aroused enormous curiosity in western Europe and the United States about unofficial art in the USSR. Komar/Melamid exhibited in this show, and in its sequel held two weeks later.

In September 1975, I moved to New York. For the past year, Komar/Melamid had been sending their work abroad whenever possible, with tourists visiting Moscow, with diplomats returning home, and in other ways. Much of it had accumulated in the New Haven apartment of Vladimir Kozlovsky, a Soviet emigré and mutual friend, and I brought it from there to New York. Aleksandr Goldfarb had recently immigrated to Israel, and as a well-known Soviet Jewish activist, he was brought to the United States and Canada to lecture on the plight of Soviet Jews. With him he carried more works of Komar/Melamid, including one piece on unprimed canvas, *Color-Writing: Constitution*, that Soviet customs inspectors had thought was a tablecloth. Goldfarb also brought a message from Komar and Melamid: they wanted to emigrate, but first they wanted to be famous. Two obscure artists from Moscow had no hope in the West, they believed, and they wanted a show in a New York gallery. Goldfarb and I should arrange it.

Goldfarb was more optimistic than I, and more persistent. Melamid will hang himself if he doesn't get a show, Goldfarb told me. But dissident Soviet artists had become fashionable as a consequence of the bulldozing of the Moscow outdoor art show, and it was not difficult to find people in New York with gallery connections who had met Komar/Melamid in Moscow. One was Marion Javits, wife of Senator Jacob Javits, who had visited Melamid's apartment and bought some work. Another was Douglas Davis, art editor of *Newsweek*, who had been introduced to Komar and Melamid by Goldfarb in 1975. Mrs. Javits recommended that we try Elon Wingate at Sonnabend Gallery. He listened, looked at slides of the work of Komar/Melamid, was not interested, and referred us to Ivan Karp at O. K. Harris, who neither listened nor looked at slides, and was not interested. Davis suggested that we try Ronald Feldman. Goldfarb visited him, explained the work, and Feldman, excited, agreed to do the show.

A few days later, Goldfarb returned to Israel, and I began four months of work with Feldman to prepare the exhibition. This required repeated lectures to convey a feeling for Soviet society, its repressive compulsions, the pretenses of its constitution, the monotony of its political propaganda, and also to make clear the meaning of the work of Komar/Melamid in its Soviet setting. These lectures, repeated by Feldman to art writers who visited the gallery, appeared in many publications.

Publicity was a problem. This was the first time that a major New York gallery had shown the work of dissident artists still living in the Soviet Union. It was bad enough that Komar and Melamid had smuggled their work to the West. It would be dangerous if the press regarded their work as anti-Soviet propaganda. On the other hand, publicity was essential. Only a reputation in the West and the attention of foreign correspondents would protect the artists once the show opened. We had to hope that reviewers would see the work as humorous, satirical, clever, even political, but political in a global sense, caricaturing capitalist and Communist, and not simply ridiculing the USSR. Fortunately, the press understood the show correctly.

It was a smash. The Komar/Melamid exhibit opened on 7 February 1976, and it covered the front page of the second section of the *New York Times* with two stories, an interview with the artists in Moscow by David K. Shipler and a review by Grace Glueck in New York. A few days earlier, Dorothy Seiberling had featured them in *New York*. The gallery was packed. Crowds of people lined up to view *Biography*, an exquisite series of 197 small wooden squares about 1⅝ inches on a side, each painted in oil in a different style, that sketched the life of a young man who, like both Komar and Melamid, was born in Moscow near the end of World War II, and who experienced a Soviet education, Stalin's purges, and adolescence and romance in Moscow. The man's life did not end, but the painted squares

stopped at a point when one period in his life had ended and a new, uncertain period would begin.

The show included several oil paintings on canvas in Sots-art style, including *Double Self-Portrait*, a large, circular painting of the artists in heroic, mosaic style, reminiscent of a portrait of Lenin and Stalin in profile. Another large piece was *Buchumov*, consisting of a large, ghastly painting signed "N. Buchumov," and 59 small landscapes painted on cardboard. Melamid and Komar had found the large painting in a trash can on a Moscow street. Unable to discover anything about the artist, they decided to write his "auto-biography" and to paint his paintings. Buchumov, they wrote, was born in the country in 1891, and later ran away to the city of Penza, where he learned to paint. He moved to Moscow to study in the School of Painting, Sculpture, and Architecture, but he was a realist surrounded by decadent abstractionists, with whom he did not agree. In an argument about art, a decadent artist accidently knocked out his eye. Buchumov returned to his native village. In 1917 he prepared and primed 60 pieces of cardboard, and decided to paint, four times a year for fifteen years, a single spot in the fields. Because his left eye was gone, his right eye always saw the profile of his nose on the left edge of his field of vision. Because he was a realist who painted exactly what he saw, his nose must appear on the left side of each of his paintings. Consequently, Komar/Melamid painted the profile of a nose on the left side of the painting they had found in the trash, and proceeded to paint 59 small pastoral scenes, the life work of Buchumov. One small painting is missing. Perhaps, in the turmoil of the Russian Revolution and the civil war, Buchumov was not able to paint it.

A rumor circulated in New York that, like Buchumov, Komar and Melamid did not exist, but were invented by dissident artists in SoHo. This rumor has not been confimed.

Komar and Melamid were famous. They had already lost their jobs in Moscow teaching art and designing books, and had difficulty supporting themselves. But their show sold out in New York, and now they had dollars. The money reached them in various ways. It is, of course, ridiculous to mail dollars directly to Moscow, unless you wish to pay a confiscatory Soviet tax. But it is possible to transfer funds indirectly. You find out what American consumer goods are most in demand in Moscow—Levi's, rock records, calculators, digital watches—and you ask a tourist going to Moscow to deliver these gifts, which can then be resold on the black market. Or you give a Soviet emigré in Israel or New York a thousand dollars, and his family in Moscow gives the desired recipient three thousand rubles—much better than the official exchange rate. By such means, Komar and Melamid survived and continued to work. Now their art was designed for export. It had become difficult to send work abroad, and so they concentrated on pieces small enough to penetrate Soviet customs—papers, photographs, works that could be constructed in the United States. Their second show opened 14 May 1977 at the Ronald Feldman Gallery, and it, too, was a success, well covered by the *New York Times* and well reviewed by the critics. But to me, the second show lacked the freshness and the energy of the first show. The colors were not as bright, the wit not as sharp. In the first show, Komar and Melamid were young, alive, clever, hopeful. It is hard not to be depressed in Moscow, and in the second show the work had become bitter and forced. The Soviet inspiration, the anti-Soviet joy, was fading. It was time to leave.

Komar and Melamid applied for permission to immigrate to Israel. In October 1977, Melamid and his family flew via Vienna to Tel Aviv. Two months later, Komar received permission to follow. Reunited in Israel, they announced their intention to build a temple in Jerusalem, in which they would sacrifice the Soviet suitcase Komar had brought from Moscow. The temple

would then be destroyed. The Soviet period of Komar/Melamid would end. They would begin to make art in the West.

I wish to thank Ronald Feldman, Marjorie Jane Frankel, and Peggy Jarrell Kaplan for their assistance in the preparation of this book. I am also grateful to Jack Burnham, who reviewed the first Komar/Melamid exhibition for the *New Art Examiner*, for accepting my invitation to write the introductory essay for the volume. *Komar/Melamid: Two Soviet Dissident Artists* was completed during the academic year 1977–78, while I was an Honorary Research Fellow in Mathematics at Harvard University, and I am grateful to Harvard University for its hospitality.

*Cambridge, Massachusetts*
*June 1978*

## Selected Bibliography

BOOKS ON RUSSIAN AND SOVIET ART

Dodge, Norton, and Alison Hilton. *New Art from the Soviet Union*. Washington: Acropolis Books Ltd., 1977.

Golomshtok, Igor, and Alexander Glezer. *Soviet Art in Exile*. New York: Random House, 1977.

Gray, Camilla. *The Russian Experiment in Art: 1863–1922*. London: Thames and Hudson, 1970.

Hamilton, George Heard. *The Art and Architecture of Russia*. 2d ed. Baltimore: Penguin, 1977.

Metropolitan Museum of Art. *Russian and Soviet Painting*. New York: Rizzoli, 1977.

Rice, Tamara Talbot. *A Concise History of Russian Art*. New York: Praeger, 1963.

Sjecklocha, Paul, and Igor Mead. *Unofficial Art in the Soviet Union*. Berkeley and Los Angeles: University of California Press, 1967.

Valkenier, Elizabeth. *Russian Realist Art*. Ann Arbor: Ardis, 1977.

ARTICLES ON KOMAR/MELAMID

Burnham, Jack. "Art of the State/State of the Art." *New Art Examiner*, May 1976.

Farrell, William E. "Soviet Immigrants Stage a 'Happening' in Israel." *New York Times*, 8 May 1978.

Fields, Marc. "Komar and Melamid and the Luxury of Style." *Artforum*, January 1978.

Friendly, Alfred, Jr. "Russian Imps." *Newsweek*, 16 February 1976.

Glueck, Grace. "Art Smuggled out of Russia Makes Satiric Show Here." *New York Times*, 7 February 1976.

————. "Dissidence as a Way of Art." *New York Times Magazine*, 8 May 1977.

Gold, Herbert. "In Russian, 'To be Silent' Is an Active Verb." *Playboy*, October 1974.

Leonard, John. "Smuggled Soviet Art Is a Witty Variation on Ideology." *New York Times*, 19 February 1976.

Newman, Amy. "The Celebrated Artists of the End of the Second Millennium A.D." *Art News*, April 1976.

Seiberling, Dorothy. "A Russian Life: Tiny Pictures at an Exhibition." *New York Magazine*, 9 February 1976.

Shipler, David K. "Impish Artists Twit the State." *New York Times*, 7 February 1976.

————. "Soviet's Solution to Pair of Satirical Artists: Give Just One a Visa." *New York Times*, 31 October 1977.

Smith, Hedrick. "Young Soviet Painters Score Socialist Art." *New York Times*, 19 March 1974.

Tighe, Mary Ann. "Art on the Line." *New Republic*, 16 April 1977.

"Satirical Soviet Artists, Reunited in Israel, to Celebrate in Rare Style." *New York Times*, 21 December 1977.

# Paradox and Politics: The Art of Komar and Melamid

## A Double Self-Portrait

The *New York Times* correspondent, David K. Shipler, quoted Vitali Komar as stating, "We're conversationalists."[1] He went on to describe the hilarious atmosphere of the apartment in a Moscow suburb where the two artists met regularly trading ideas in what seemed to be almost cabaret improvisation.

"We are not artists," Aleksandr Melamid interjected, waving his hands at the dozens of paintings and graphics on the walls around them. And certainly explaining their works in deliciously ironic detail was, and still is, a major aspect of their "art." As the British artist and theoretician Victor Burgin has reminded us, Western art practice has become polarized between *modernism* (the various modes of figurative expressionism and abstract formalism) and what might be loosely termed as *conceptualism*.[2] Conceptualism includes virtually much of what is not overtly painterly or sculpturally contrived. Much video, performance art, photographic and written documentation, conjecture by artists on the infrastructure of art world politics, plus the interface between art and the "real world" fall into this omnifarious category. Conceptualism has become art without the esthetic veils of propriety which ultimately made modernism socially and financially acceptable. It has, as Burgin reminds us, become the revolutionary cutting edge of Western art, if only on an *ad hoc* basis. More than likely conceptualism's rampant subjectivity prevents it from ever becoming monolithic and left-wing vis-à-vis bourgeois esthetics. Like hordes of microscopic amoebae, conceptualist postures seem to partition or fragment almost as soon as they are formulated. In the West, Marxist-oriented sociopolitical writing has become a dominant style of 1970s "conceptualism," as a form of endless ingroup polemics.

Given the shop-worn state of much new art in 1978, it is perhaps inevitable that the issues of politics and artists' survival should again emerge, becoming active after a thirty-year sleep. Still the notion that artists and art can be saved, or discarded, through acute Marxist analysis is implicitly questioned by the two exhibitions held in 1976 and 1977 at the Ronald Feldman Gallery in New York City. Much of the initial Western press attention directed toward the art of Komar and Melamid was in obvious response to the unprecedented audaciousness of their position relative to the Soviet art establishment. The vigor and innovativeness of their thinking can only be understood if one is cognizant of the state of all other dissident art in the Soviet Union. But this is a subject of some interest which we will review later.

In spite of the satire and humor of these exhibitions, they tell us reams about the underlying and real conflict that exists between art and political ideologies—*both in the East and the West*. It's clear once again that art resists being saddled with political "isms"; art, if anything, revels in paradox and anarchy. Given the polarizing tensions between communism and capitalism, the thinking of these artists cuts into the flabby, rhetorical assumptions of both sides. Their "Third World Alternative" really amounts to a mirthful disintegration of these ideologies into a kind of blank, paradoxical fusion, or perhaps *confusion* sums it up. The concrete results of Komar and Melamid's thinking would not be possible without the present-day anarchistic license of Western esthetics, at the same time the cutting edge of their transcendental satire depends upon the repressive tendencies of Soviet life. In their case, one needs the other.

The two are virtually "nonpersons" or "nonartists" in the Soviet Union, having lost their positions in 1972 as junior members of the Artists Union. According to Grace Glueck, art writer for the *New York Times*, "Komar and Melamid (both are in their early 30's, one Jewish, the other partly

1. "Impish Artists Twit the State," *New York Times*, 7 February 1976.
2. "Socialist Formalism," *Studio International*, 191, no. 980 (London, March–April 1976): 146–54.

so) have earned their statelessness in the eyes of Soviet officials, although they started out as proper young Soviet citizens. A decade ago, after graduating from approved Moscow art academies, they dutifully joined the Youth Section of the Soviet Artists Union to paint in the recognized style of Soviet Socialist Realism.

"But gradually their work became more experimental. Operating as a team, they turned to satirizing the ideological thrust of Soviet propaganda art, painting jointly the strapping, heroic workers, the charts of production achievement and the mosaicized heads of Lenin and other Soviet idols found on billboards and façades all over the country. In 1972, when they showed some of their tamer ventures to officials of the union, asking for a one-day show, they were not only turned down, but kicked out."[3]

For Americans with no real sense of the Russian language or culture their first New York exhibition in 1976 appeared to be blatant Soviet Communist propaganda. Blazing red and white banners bedecked the hallways of the gallery proclaiming "Onward to the Victory of Communism," "Glory to Labor," and "We Were Born to Turn Dreams into Reality," each banner signed by the two artists and each possessing equivocal meanings, "labor" and "dreams" having other implications for Western art workers. In a society where Socialist Realism is not only the norm but the wage-earning rule, Komar and Melamid insisted that "we are realists, and the source of our art is Soviet mass culture, which is not understood by a foreigner. Besides we have a different art tradition which is not easily grasped by people who were brought up on Jackson Pollock and Arshile Gorky rather than monumental statues of Stalin."[4] Here they are using the term "realists" with the double-edged irony of an attempt to seek reality beyond an ersatz, socially proscribed "ideal reality."

In 1972 a young American mathematician, Melvyn Nathanson, in Moscow on a postdoctoral fellowship, discovered the work of Komar and Melamid and proceeded to bring it to the attention of various Americans.

Aleksandr Goldfarb, Melamid's cousin and a Russian biochemist since immigrated to Israel, actively worked to attract sympathetic members of the Western press. During this period the artists were confined to showing their art to a few friends and fellow artists in their apartment.

Goldfarb has pointed out that the mechanisms which shape taste and desire in the United States or capitalist European countries are the same in Russia, China, or the other socialist countries. The devices are outdoor advertising, stores, radio, magazines, television, newspapers, and virtually dozens of other subliminal "message" indicators, in essence the "mass media." In the West the goal of media pressure is a higher rate of consumerism, while in Russia the desired goals are personal sacrifice, belt-tightening, increased production, and future consumer benefits; quotations stem from the writings of Lenin rather than the iconic phrases "Drink Coca-Cola" or "Modess Because."

Brand-name identification is the desired result in both cases. In the early 1960s, Andy Warhol was interviewed by Gene Swenson, the critic, at which time Warhol made the oft repeated observation: "Someone said that Brecht wanted everybody to think alike. But Brecht wanted to do it through Communism, in a way. Russia is doing it under strict government; so if it's working without trying, why can't it work without being Communist? Everybody looks alike and acts alike, and we're getting more and more that way."[5]

Similar to American intellectual tastes, the educated classes of Russia have been conditioned

3. "Dissidence as a Way of Art," *New York Times Magazine*, 8 May 1977.
4. A report by the Russian microbiologist, Aleksandr Goldfarb, included in an article, "A Russian Life: Tiny Pictures at an Exhibition," by Dorothy Seiberling, *New York*, 9 February 1976, p. 42.
5. "Andy Warhol, an Interview with G. R. Swenson," in *Pop Art Redefined*, edited with an Introduction by John Russell and Suzi Gablik (New York and Washington: Frederick A. Praeger, 1969), pp. 116–19.

to either ignore constant political messages of Soviet mass culture or their selectivity to such information is very finely tuned. Komar and Melamid insist that "He [the Soviet intellectual] will never admit that the aesthetics of ideological advertisement frame his perception of the world. In the Happening [informal events which the artists have organized in Moscow], we had overcome the student's instinctive negative attitude to *Pravda* in general, and to the advertisement of the Minsk plant in particular. After they finished, they admitted that their major concern was not to look funny. Therefore, they psychologically transferred all responsibility for their actions to us, the people who gave directions. As a result, they sincerely tried to do their best. The success of this venture indicates how effectively they had absorbed the images of mass ideology."[6]

The happening referred to centered on a large, red-painted canvas placed on a brightly lighted stage. There three masked students who had never held a paint brush were "directed" by loudspeakers to illustrate an article from *Pravda*. The article dealt with a newly completed industrial plant in Minsk. As the piece was read, a tape recorder played patriotic marches and the audience was allowed to comment on the progress of the painting. Very much like self-criticism sessions held on a neighborhood level in China, work stopped and a public discussion ensued when it was felt that one of the student painters had worked against the optimistic mood of the article. Only with an acknowledgment of error was the painter allowed to continue. Except for some happenings staged during demonstrations of the Vietnam War, it is difficult to remember artistic events in the United States of equal sardonic value. Certainly advertising is the chief target of American satire, but it is difficult to ridicule an institution which is already so prone to self-parody.

In an article Aleksandr Goldfarb describes a large painting by Komar and Melamid which has not been exhibited in the United States. In a sense, this is a study of the nuances surrounding the mannerisms and stylistic taboos of Socialist Realism. Goldfarb writes, "In one of their works, *The Meeting between Solzhenitsyn and Böll at Rostropovich's Country House* (1972), Komar/Melamid analyzed the people of their own circle, the intellectuals. A major characteristic of the Soviet intellectual is a mental eclecticism that comes from being steadily exposed to experiences which, logically and aesthetically, are incompatible with each other. For example, in a single day a student of Moscow University is apt to be subjected to a math lecture dominated by rationalism and objectivity; a Komsomol meeting, where he listens to a speech in the style of mass-ideology advertising; off campus, a huge poster which proclaims "The Party and the People Are United"; in a museum, a show of French impressionists. His day may end with a Kafka novel and begin with the newspaper *Pravda*. Thus, his life consists of an array of influences that correspond to different mental systems and different aesthetic stereotypes which help him to recognize the messages on a subconscious level even before he reacts consciously to evaluate them as "good" or "bad."

What Goldfarb is alluding to is the schizoid consistency of all contemporary Western culture, but particularly that which is bound by the dogmatic and compartmentalized routines of Soviet culture. Thus the art of Komar and Melamid is eclectic in a special sense of the word. The very mixture of influences—for example, Byzantine icons, Renaissance and Baroque painting, capitalist advertising, Soviet posters and documents, nonobjective art, plus the subtle confusion of bureaucratic prose with an undercurrent of Judeo-Christian mysticism, give it a special disjointed sense of ludicrous absurdity. Their art produces *confusion* in the etymological sense of "pouring together," of producing a mixture of such disorder that the key becomes the recognition of primal

6. Seiberling and Goldfarb, "A Russian Life," p. 42.

paradox, that is of paradox being at the core of existence.

In a society, the Soviet Union, which has made dogma of rejecting indulgent materialism (Karl Marx's "fetishism of commodities"), Komar and Melamid have raised a corner of the curtain to what is physically repressed by such restrictions. The German critic Walter Benjamin is responsible for the observation that all commodity fetishism—whether it is in art or any other consumer goods—stems from an object's ability to be invested with an "aura," or that which creates a veil of distance, desire, ritual protocol, and mystification. "Aura" is normally invested with a love-hate duality for the desiring party; it is craved because it brings immediate satisfaction, but despised because the satisfaction is always temporary. Ideological fetishism feeds the brain and starves the senses; consumer fetishism does the reverse. And it is this inversion that Komar and Melamid play with so skillfully in their art.

Perhaps the irony of Komar and Melamid's esthetics is that they have been doing since 1972 what some Western artists, such as Hans Haacke, Victor Burgin, Daniel Buren, and Klaus Staeck, have also attempted in the context of liberal capitalism. During the mid-1960s the philosopher Herbert Marcuse made such terms as "harmonizing pluralism" and "repressive tolerance" ideological slogans for the New Left. At the same time Marcuse had no illusions about Socialist Realism; "Hegel saw in the obsolescence of art a token of progress. As the development of Reason conquers transcendence ("takes it back" into Reality) art turns into its own negation. Soviet aesthetics rejects this idea and insists on art, while outlawing the transcendence of art. It wants art that is not art, and it gets what it asks for."[7]

Like Komar and Melamid, it is evident that artist-critics such as Victor Burgin realize that Western art history has arrived at a dramatic hiatus, if not a complete cessation. More and more, new art becomes a critical synthesis of old

art; as mechanisms of ideology the study of art and advertising tend to merge, their internal "messages" evidence considerable homogeneity. In regard to Western advertising Burgin writes, "Although we cannot currently affect the publicity messages emitted, we may subvert the messages received. A task for socialist art to unmask the mystifications of bourgeois culture by laying bare its codes, by exposing the devices through which it constructs its self-image. Another job for socialist art is to expose the contradictions in our class society, to show up what double-think there is in our second-nature. Qualifications for the first job include a knowledge of semiotics; qualifications for the second job include a knowledge of politics and economics."[8] Perhaps by relying more on humor and intuition than academic qualifications, Komar and Melamid have assumed the task as outlined by Burgin, but their target is Soviet society where the capacity for double-think is far more regimented.

## Socialist Realism

To understand properly the context of Komar and Melamid's art in the Soviet Union, it is worth reviewing some of the history and doctrines of official Russian art during the past sixty years. The irony of Russian art during the early twentieth century is that in many instances it proved to be more radical and more conceptually revolutionary than its parallel in Western Europe. Rayonism, suprematism, constructivism, and productivism represent the nuclei of forces which have played a vital role in Western art during the last half century. Until recently, the history of Russian art leading up to the October Revolution of 1917, and its demise in the early 1920s, was fragmented and obscure, interpreted mainly

7. Herbert Marcuse, *Soviet Marxism: A Critical Analysis* (1958; reprint ed., New York: Random House, Vintage Edition, 1961), p. 116.
8. Burgin, "Socialist Formalism," p. 154.

through the eyes of Russian exile artists. The turning point came with the publication of the English art historian Camilla Gray's book, *The Russian Experiment in Art: 1863–1922*, in 1962. The significance of a number of Russian artists, long ignored by the Soviet State, only came to light in the West with this study. Our knowledge of early Russian vanguardism has grown considerably with the publication of many catalogues and anthologies in subsequent years.

During the first years of the Revolution, known as the period of "heroic Communism," countless agencies were set up by the Bolsheviks to deal with the problems of organizing cultural activities. The concept of *Proletkult* (Organization for Proletarian Culture) was conceived in 1906 by the young critic Aleksandr Malinovsky. As a reaction to nineteenth-century "Art for Art's Sake," *Proletkult* was an attempt by Russian intellectuals, influenced by the latest Western artistic trends, to reeducate culturally the Soviet masses in every aspect of life. *Proletkult* flourished in the early 1920s in its attempt to fuse art and industry, but even as early as October 1920 it was forced by Lenin to submit to Party administration under Anatoli Lunacharsky, then director of *Narkompros* (Commissariat of Enlightenment). In a sense the history of these early years is a chronicle of the debates which took place at *Inkhuk* in Moscow (Institute of Artistic Culture) between the idealist "leftists," including Kandinsky, Malevich, Pevsner, Gabo, Lissitsky, Shterenberg, and Altman, and the "ultra-leftists" including Tatlin, Rodchenko, Stepanova, Popova, and Vesnin. This polarity took the form of a conflict between idealist "laboratory art" on one hand and industrially oriented "production art" on the other. By the late 1920s most of the Productivists had been subsumed into the needs of Soviet media and industrial design. Others such as Gabo, Pevsner, Lissitsky, Chagall, and Kandinsky soon immigrated to the West.

As early as 1905 Lenin had written that "Literature [read art] must become a 'part' of the general proletarian cause, the 'Wheel and the Screw' of a single great social-democratic system, set in motion by the entire politically conscious vanguard of the whole working class."[9] Lenin, like Plato, saw no harm in making art subservient to political judgment, just as its value to the State depended upon its accessibility to the uneducated masses, not to the tiny Russian intelligentsia. Given Lenin's education and background, as with much of the Party hierarchy, only an eminently illustrative art such as nineteenth-century academic realism fulfilled the need for an art which also embodied nationalist traditions, beyond the immediate usefulness of the crude but powerful agitprop poster style. Maxim Gorky, at his *dacha* during a visit by Stalin, is credited with inventing the term "Socialist Realism" as a theory which embodied both practical political needs and Marxist ideals. In 1932 the direction of Socialist Realism was consolidated by the triple stipulation of *partinost* (party character), *ideinost* (Socialist content), and *narodost* (national roots).[10]

By the early 1930s all art styles in the Soviet Union except Socialist Realism were viewed as concessions to bourgeois ideology. The personality of the individual artist became subservient to the goals of Marxist doctrine and mass reeducation. Subjective reality gave way to a method of depicting an "objective" if assuredly optimistic Communist reality. The "method" of Socialist Realism essentially deals with content, minor variations in realistic technique and expression remain the province of individual artist. According to the authors Sjeklocha and Mead in their study, *Unofficial Art in the Soviet Union*, the Soviet artist is considered to be another production worker who is trained to understand "the laws of social development."[11]

They illustrate this by asserting that, "In view

9. Paul Sjeklocha and Igor Mead, *Unofficial Art in the Soviet Union* (Berkeley and Los Angeles: University of California Press, 1967), p. 27.
10. Ibid., pp. 30–31.
11. Ibid., pp. 29–36.

of the restricted range of subject and style made available to the artist by the precepts of socialist realism, in addition to the official artistic homage paid to Lenin and Stalin, the artist's choice of subject was almost entirely confined to the general theme of the 'new Soviet man' and the 'new Soviet Society' depicted by scenes of industry, construction, and collective farm work.

"Landscapes, seemingly a nonpolitical subject, were only permitted if they showed the countryside in 'Socialist transformation' using such devices as dams or electric power stations. All portrayals had to be optimistic because the victory of the proletariat had been achieved—'negative pessimism' was not permissible. Already the artist, in accordance with official dogmatism, had to accept and guide himself by the immutable law of 'kritika i samokritika' (criticism and self-criticism) in which he knew what to paint and what not to paint. In other words, he had become his own personal state censor."[12] After returning from the USSR in 1964 the art editor of the *New York Times*, John Canaday, wrote a series of columns on his visit. Possibly the most facinating one described the censorship process employed by the Artists Union in regard to art which had been officially commissioned. Most infractions of an ideological or plastic nature were purely unintentional, but obviously, according to Canaday, some artists had gone to ingenious, Kafkaesque lengths to slip in their personal "messages" whatever their nature.

Philosophically the justification for Socialist Realism lies in Lenin's "theory of reflection" derived from the dialectic materialist concept of cognition. According to Lenin's *Materialism and Empirio-Criticism*, matter has an objective reality separate from human consciousness. As viewed by the contemporary Soviet esthetician Mikhail Ovsyannikov, consciousness stems from the concrete world around it and not from internal sensations. He quotes from Lenin: "Consciousness *reflects*—this is the basic premise of all materialist philosophy."[13] Within the tradition of Western

modernism the two great enemies of Socialist Realism have been formalism, as expressed in nonobjective painting and sculpture, and the dreamlike subjectivism of surrealism. In Soviet terms, both sacrifice the communication of an objective (Socialist) reality for the *inner world* of the artist which in Western modernist esthetics becomes the one, absolute reality. Progressive disintegration of the representational image is interpreted by Soviet art critics as an overt sign of the disintegration of capitalist society. Formalism and surrealism for the Soviet critic are "neomythologies" rooted in either a *poetic* presentation of social conflict or a *mystical* interpretation of reality, both of which are invalid in terms of a materialist esthetics.

The Soviet art critic Vladislav Zimenko, editor in chief of the influential magazine *Iskusstvo* (*Art*), has dealt with modernism in his book, *The Humanist Tradition in Art* (1976). There is no little irony to the fact that much of what he says in his attack on Western art would be easily supported by many citizens of capitalist countries. Zimenko writes: "The spread of Abstract Art and Surrealism, and their sensational success in narrow circles of rich collectors and snobbish bourgeois intellectuals are indicative of the deepening crisis of bourgeois society and culture. The latter is becoming markedly anti-humanistic in character, partly due to its philosophical basis, which as a rule, consists in the most extreme and militant forms of subjective idealism.

"The art of blind, dark, anti-human instincts, pessimistic negation and hopeless casting around in the gloom is flourishing in bourgeois society today. That this is affectation, madness or charlatanism, need hardly be said. There is undoubtedly an element of all three in it. There is also cold calculation; the market exists for that sort of commodity, and it is being delivered. But Ab-

12. Ibid., p. 45.
13. Mikhail Ovsyannikov, "The Artistic Image," in *Problems of Modern Aesthetics* (Moscow: Progress Publishers), 1969, p. 216.

stract Art (and Surrealism, too) is also a mistake. Not a personal mistake of a few misguided artists, but the historically conditioned error of many artistically gifted natures of our time, educated in the conditions of a deepening crisis of the capitalist social system."[14]

As interpreted by the editor-critic Zimenko, "humanism" is the crux of the esthetic difference between art which supports and encourages the best in human aspiration, namely Soviet art and some earlier European art with decidedly political overtones, and the pessimism of bourgeois contemporary art, specifically abstract formalism. Zimenko elaborates with the statement, *"Humanism is not an abstract category where class differences and political tasks and goals somehow do not apply, as some bourgeois ideologists are wont to contend."*[15] In other words, humanism for the Socialist realist implies art which supports Marxist ideals, and accomplishes this through essentially representational means. The last is, in a sense, compatible with advocates of figurative realism in the United States who propose a "New Humanism." This humanism, however, simply relates to formalist and psychological concerns through the depiction of human forms. Yet in the West there is a substantial body of art which is quasi-abstract or conceptually oriented but which embodies liberal or left-oriented aspirations. So Soviet art must "reflect" life in the sense that it focuses on the optimistic aspects of Socialist society. It cannot accept the assertion by some bourgeois critics that the nonconformity of modernism is a way of "creating" new societal values. For the Soviet critic the "eternal romantic mutiny" is no more than a withdrawal by the artist from the acceptance of social responsibility. Most ironically these same critics view Socialist Realism as an open, flexible concept, nonmonolithic in allowing great flexibility of content and style. Obviously if one scans the last chapters of Zimenko's book or views the recent exchange exhibition of Russian art at the Metropolitan Museum in New York City (sum-

mer 1977), a considerable degree of abstraction has permeated recent Soviet painting thought acceptable for public viewing. Some of this is derived from Fauvism, German expressionism, and Russian vanguard art of the early twentieth century. Such art adheres to some representational convention and finds its justification in the various forms of figurative stylization prevalent throughout Western art history. Exponents in the Soviet Union regard the inclusion of quasi abstraction in recent Socialist painting as "expanded realism" as opposed to "limited realism."

## Soviet Dissident Art

The esthetic quality of official Soviet art has been most cogently questioned with the publication in 1959 of the essay, *On Socalist Realism*, smuggled out of Russia and published under the nom de plume of Abram Tertz. In 1965 the actual author of this quasi-political tract, the literary critic Andrei Sinyavsky, was sentenced to prison for sending "slanderous" manuscripts out of the country to be published in the West. Even in the face of strong letters of protest to the Soviet government by eminent members of the Western literary establishment, the Twenty-third Congress of the Soviet Union adjudged such writing as giving "ammunition to reactionary propaganda," as indeed it did in Soviet terms.[16]

The major artistic criticism which Andrei Sinyavsky leveled against Soviet art and literature was *eclecticism*, Socialist Realism's reliance on nineteenth century literary and artistic models for its own creations. Sinyavsky writes near the closing paragraphs of his book, "It seems that the very term 'socialist realism' contains an insoluble contradiction. A socialist, i.e., a purposeful, a reli-

---

14. Vladislav Zimenko, *The Humanism of Art* (Moscow: Progress Publishers, first English printing, 1976), p. 77.
15. Ibid., p. 7.
16. Sjeklocha and Mead, *Unofficial Art in the Soviet Union*, p. 201.

gious, art cannot be produced with the literary method of the nineteenth century called 'realism.' And a really faithful representation of life cannot be achieved in a language based on teleological concepts. If socialist realism really wants to rise to the level of the great world cultures and produce its *Communaid*, there is only one way to do it. It must give up the 'realism,' renounce the sorry and fruitless attempts to write a socialist *Anna Karenina* or a socialist *Cherry Orchard*. When it abandons its effort to achieve verisimilitude, it will be able to express the grand and implausible sense of our era." [17]

In 1957 Mao Tse-tung wrote his famous essay, on "Letting a Hundred Flowers Blossom," and "Letting a Hundred Schools of Thought Contend." Mao's dictum prefaced a slightly more liberal policy toward the arts in China and anticipated the artistic "thaw" in the Soviet Union by two or three years. However, as slogans of Marxism's newly found largess they echo Henry Ford I's remark that he would continue to make Ford automobiles any color people wanted *as long as they were painted black*. In the same spirit of esthetic flexibility Mao writes, "Plants raised in hot-houses are not likely to be robust. Carrying out the policy of 'letting a hundred flowers blossom and a hundred schools of thought contend' will not weaken but strengthen the leading position of Marxism in the ideological field. What should our policy be towards non-Marxist ideas? As far as unmistakable counterrevolutionaries and wreckers of the socialist cause are concerned, the matter is easy; we simply deprive them of their freedom of speech." [18]

Since the early 1930s the Artists Fund and the Artists Union have controlled the productivity of art by rewarding art based on realism and acceptable Socialist themes. Prerevolutionary masterpieces include Ilya Repin's *Haulers on the Volga* (1873), while the outstanding early Soviet painter is Aleksandr Deineka whose *Defense of Petrograd* (1928) and other paintings of the 1920s

admittedly owe a debt to cubism and constructivism. Some masterful portraiture exists in the style of Socialist Realism, for instance, Isaak Brodsky's *Lenin in the Smolnyi Institute* (1930). However, artists such as Aleksandr Gerasimov, Stalin's court painter, Arkady Plastov, the Soviet Millet, Gely Korzhev, humanist par excellence, or Kuzma Petrov-Vodkin, the figurative painter, are the best that the Soviet Union has to offer and the best is none too interesting. In terms of their public accessibility and popularity these artists roughly parallel the illustrative realism of the American artists Norman Rockwell, Peter Hurd, Grant Wood, and Andrew Wyeth. At its worst, Soviet painting might be judged by the criticism leveled against it by the chief art critic of the *New York Times* in his review of the exchange exhibition *Russian and Soviet Painting* at the Metropolitan Museum of Art. Hilton Kramer begins by questioning the integrity of a museum that would show "for the most part . . . . mediocre (or worse than mediocre) paintings." [19]

Given the low esteem most Western art historians have for Russian art between the seventeenth and nineteenth centuries, Kramer acknowledges the value of certain early twentieth-century Russian paintings, and asserts, "My own pleasure in seeing these pictures is somewhat clouded by a consciousness of the cynical political uses to which the Soviet government puts these pictures abroad while continuing to treat every effort to revive the modernist tradition at home as a sign of anti-Soviet activity." Kramer then adds, "The more or less contemporary section of the exhibition is dominated, of course, by the kind of painting that meets with the government's approval, and these are propaganda pictures of the

17. Abram Tertz [pseud. for Andrei Sinyavsky], *On Socialist Realism*, trans. George Dennis, with an Introduction by Czeslaw Milosz (New York: Random House, Pantheon Books, 1960), p. 91.

18. Mao Tse-tung, *Mao Tse-tung on Art and Literature* (Peking: Foreign Languages Press, 1960), pp. 141–42.

19. Hilton Kramer, "Detente Yields a Dismal Show," *New York Times*, Sunday Art View Section, 24 April 1977.

most abysmal quality. From Pimenov's 'Give to Heavy Industry' (1927) and Brodsky's 'Lenin in the Smolnyi Institute' (1935) to Nalbandian's official portrait of Brezhnev and Pokhodaev's ludicrous picture of the Soyuz and Apollo astronauts (both 1976), there is a steady decline of competence without any visible weakening of the ideological line. This is painting produced in an aesthetic moral void, and it is a scandal for our leading museum to show it."[20]

In response to Kramer's condemnation of the Metropolitan Museum for exhibiting Soviet art, his censuring is much in the spirit of the reproaches leveled by Soviet critics at the vast majority of Western art. Good or bad, it is considerably more important that Americans see Russian art, especially art deemed worthy by Soviet bureaucrats, than that we not see it because of its alleged esthetic shortcomings. Education is only possible through the making of choices, exclusion of choices simply breeds ignorance, as has so often been the alternative within Communist countries.

Sjeklocha and Mead stress in their book, _Unofficial Art in the Soviet Union_, that since the "thaw" of the early 1960s, there has been a growing underground in the Soviet Union of unofficial artists, also an underground market for such work. Given the power of the Artists Union, its disbursal of commissions, the payment of royalties, and the awarding of special housing and educational privileges to favored artists, relatively few artists working in the Soviet Union are recognized. Many more make art an avocation while working in the commercial, applied, or decorative arts—such as Komar and Melamid before the loss of their jobs. Survival for the artist in the Soviet Union becomes exceedingly difficult in this instance, and the problem then is not to be branded as a part of the unemployed criminal element. Dissident or "marginal" artists in the Soviet Union, however, have very few opportunities to exhibit or sell their art. While the USSR no longer completely stifles all art influenced by modernist tendencies, unless such work is politically subversive, it can economically discourage its propagation, and does.

Given the cultural provincialism of former Premier Nikita S. Khrushchev, it is to Khrushchev's everlasting credit that he eliminated many of the more stultifying aspects of "Stalinism" during his tenure between 1957 and 1963. Khrushchev's toleration of artistic freedom was certainly not liberal by Western standards. Still the "great thaw" of 1959–62 released a promising trickle of new novels, experimental poetry, and abstract art which would have been unthinkable under Stalin. Small evidences of revolutionary and prerevolutionary modernist art which had been in storage in public museums for over thirty years began to appear. The Soviet Union had amassed numbers of major paintings by such artists as Monet, Gauguin, Cezanne, Matisse, and Picasso with the earlier confiscation of private collections. A key event to the cultural relaxation occurred with the opening of the Picasso retrospective at the Pushkin Museum in Moscow in October 1956. Such writers as Ilya Ehrenburg collected Picasso's early art and during the 1950s championed the liberal creative element in the Soviet Union. Ehrenburg's novel, _The Thaw_ (1954), was bitterly attacked by the conservatives within the Writers Congress for its damning perspective of the Staninist era, a condition only secretly verified by Khrushchev in his famous speech before the Twentieth Congress of the Communist Party in February of 1956.

Possibly the downfall and repression of the artistic intelligentsia came with the so-called "Manège affair" in December of 1962. Liberals in the Ministry of Culture successfully organized an exhibition at the Manège Gallery located just off Red Square. The work of artists hitherto suppressed was placed on exhibit along with examples of more orthodox art, the hope being that the former would at least gain tacit approval

20. Ibid.

of the Soviet hierarchy. Khrushchev appeared at the opening along with several presidium members and members of the Party secretariat to see "Thirty Years of Moscow Art," an exhibition containing over two thousand paintings and sculpture. It is reported that during the initial aspects of the inspection of art Khrushchev was occasionally irritated, but on the whole restrained in his reactions. As the premier entered the galleries housing the more abstract art, he lost control of himself. Explanatory remarks by Ernst Neizvestny, the leading abstract sculptor in the Soviet Union at the time, only infuriated Khrushchev all the more. Interspersed with choice vulgarities, the substance of Khrushchev's remarks were that the State had been wasting its money on untalented perverts and that it would be better for the artists in question and the Soviet Union if they applied for passports and emigration visas. Denouncing the art as "pathological" and anti-Soviet, Khrushchev uttered this notable remark, "One isn't able to tell if they were drawn by the hand of a man or smeared by the tail of a donkey." Even the premier's son-in-law, Aleksei Adzhubei (editor in chief of *Izvestia* and also a collector of modernist art), was silenced when he tried to explain the intentions of the work. It is the opinion of Sjeklocha and Mead, who give a full account of the incident, that the "Manège affair" was not contrived by reactionaries but was simply the last straw in Khrushchev's realization that artistic license and liberalization had ceased to serve the needs of the Soviet State.[21] In the wake of enormous public interest to the Manège exhibition and the ensuing cultural freeze, it is ironic that the sculptor Neizvestny was invited to Khrushchev's dacha after the premier's forced retirement, the two were to become friends. After the premier's death, Khrushchev's family commissioned Neizvestny to carve a monument for his grave, due probably to the enlightened views of Adzhubei and his wife. Neizvestny emigrated from the Soviet Union in 1976 and is now living in Zurich and New York City.

One has to admire the collectors of art by unofficial Soviet artists as one admires the courage and perseverance of the artists themselves. Through the years George Costakis and Alexander Glezer have both built authoritative collections. The range of dissident and marginal art utilizing representation spans the gamut from highly stylized surrealism to naïve and neo-primitive realism. Until the early 1960s when tachisme and abstract expressionism were discovered by Soviet artists through Western art magazines, the dominent modern tendency was, and to some degree still is, the influence of the *école de Paris*. By Western standards much of the art with this bias tends to be timid and thoroughly derivative, which only supports the contention that esthetically art does not "travel well," like wine, when transported from its intellectual context. Between 1962 and 1972 the Soviet artist, Lev Nussberg, organized the Movement Group-Moscow which derived its heritage of kinetic art from the early Russian constructivists. Nussberg's research, as generally unknown as it remained in the West, very much paralleled the reemergence of kineticism in Europe and the United States during the same period. Possibly the most unique unofficial art in the Soviet Union is the work of various regional artists who represent specific religious or geographical situations. For instance, there is the art of Evgeny Abezgauz, a graduate of the Leningrad Industrial Art Institute, whose art deals with biblical and contemporary themes of Jewish life. His painting is neo-primitive, not unlike early Chagall in spirit and originality, and it compares favorably with its counterparts in the West. An examination of the catalogues and biographies compiled on dissident Soviet artists reveals that West Germany has hosted a considerable number of such exhibitions. These efforts help to keep the nonreactionary Soviet artistic climate alive.

To be sure, the Soviet artistic milieu is not

21. Sjeklocha and Mead, *Unofficial Art in the Soviet Union*, pp. 85–102.

absolutely black and white; party hacks versus dissidents. A case in point is the "marginal" but highly popular painter, Ilya Glazunov. Like Grant Wood or Thomas Benton in the United States, Glazunov paints the nationalistic traditions of Russia which makes him acceptable to the people and to many in the Soviet political hierarchy. There are strong hints of the Russian-Byzantine style in his painting, although his larger paintings are not unlike the great mythical-historical machines of the French romantic painter Anne-Louis Girodet-Trioson with their sunbursts and swirls of mist. Glazunov, although a patriotic realist, was consistently rejected for membership by the Artists Union, officially because of the religious fervor of his painting, if not for professional jealousy, and has only been accepted in the last few years. In late June 1977, a large-scale Glazunov retrospective of three hundred paintings was expected to open in Moscow. The artist was asked by the Ministry of Culture and the Artists Union to withdraw four of his paintings, including a canvas entitled *The Mystery of the Twentieth Century*. Among the scores of figures in this canvas are the forbidden images of Joseph Stalin, the assassinated Leon Trotsky, the exiled Aleksandr Solzhenitsyn, Pope John XXIII, and Jesus Christ. Rather than excluding four of what he considered to be his "masterpieces," Glazunov canceled his exhibition.

## The Komar/Melamid Exhibition, New York, 1976

On 20 February 1976, the first foreign "one-men" exhibition for Aleksandr Melamid and Vitali Komar opened at the Ronald Feldman Gallery in New York City. According to Alfred Friendly, Jr., *Newsweek*'s Moscow correspondent, the two were elated but scared stiff that their gentle satire and anti-Soviet spoofs were to be seen for the first time outside the Soviet Union.[22] During the exhibition Feldman talked with the two artists via transatlantic telephone with the aid of a transla-

tor. The artists thought that they might become prime candidates for a mental ward with the closing of their show. However, the publicity received in the United States may very well have protected them. In his interview with Alfred Friendly, Melamid is reported to have said, "We are children of peaceful coexistence, and thanks to that we can survive even if we act like children who don't behave and get swatted with a cane sometimes." The artist added, "A reputation is necessary for our creative work. The more we are heard, we more we can say."[23]

During the same interview Komar spoke of the esthetic paradox involved in revealing the underlying inconsistencies of the two cultures, "Ours is the art of incongruity, for we are the middlemen of East and West. Unlike many Russian artists, we believe there is a world culture. We have always tried to work with that view, without making allowances for our aboriginal culture. Russians see us as a grimace from the West. Foreigners see us as a smirk from the East. Our art has to be eclectic, for its elements are incompatible. The humor comes from the clash between an unsuitable container, détente, and its unadaptable contents, Russia."[24]

How does one interpret the blatant pastiches and rampant eclecticism of Komar and Melamid? The art historian George Kubler has defined the problem of historical significance in his book *The Shape of Time* as a matter of the proper historical "entrance" for the artist, and similarly Komar and Melamid believe that timing and circumstances make great painting. Thus, if art history, or at least Western vanguard art, is finished in some essential sense, then more and more of what is produced as art must assume the guise of eclectic revival or critical retrospection. As with most art ideas, eclecticism was practiced by artists long before it was recognized by critics and

22. Alfred Friendly, Jr., "Russian Imps," *Newsweek*, 16 February 1976, p. 89.
23. Ibid.
24. Ibid.

historians, being first employed by Johann Winckelman in his *Treatises* (1764). As a post-Renaissance esthetic it meant the selection of all that was best from a variety of artists, ideas, and styles; its purpose, a higher synthesis. With Komar and Melamid's adaptations of Pop and conceptual art, the goal is the transcendence of the East-West ideological schism through the spiritual, and often mystical, values embedded in their art. The expropriation of vanguard styles is the vehicle for truths incidental to political ideologies.

The uniqueness of Komar and Melamid lies in the fact that somehow their work transcends the Soviet avant-garde with its proclivities toward tachisme, expressionism, and early constructivism, art which is ten to forty years out of phase with present art in Western Europe and the United States. Their rapport with the West was best described by the critic Amy Newman when she wrote about the two: "Their touch is brilliantly cool and ironic, their satire and iconoclasm not tied to any ideology other than one of creative expression. . . . Their art breathes a subdued confidence. It is a new breed of 'dissident' art: there is nothing shortsightedly polemical, tortured or pathetic about it."[25]

As early as the middle 1960s there are evidences of a Soviet Pop art, but in comparison with the best examples in the United States it tended to be obscure, tentative, and vaguely abstract. In the spirit of Pop during the period of 1972–73 Komar and Melamid defined their art as "Sots" art, an acronym of the first letters in Russian for "Socialism." Their earliest painting at Feldman was entitled *Laika Cigarette Box* (1972), an enlargement of the design used on a package of *Laika* cigarettes, after the ill-fated dog which was lost on a 1957 *Sputnik* orbiting. The *Laika* painting is expressed somewhat in the style of early rayonism, as found in the paintings of Natalia Goncharova and Mikhail Larionov. The rayonist esthetic being quasi futurist as expressed by Larionov in the rayonist manifesto of 1913:

"We declare: the genius of our days to be: trousers, jackets, shoes, tramways, buses, aeroplanes, railways, magnificent ships—what an enchantment—what a great epoch unrivalled in world history."[26] So in a sense, the *Laika* painting is an attempt to wed space-age Soviet technology to the first homages paid to technology by Russian art sixty years ago. Still it lacks the dryness and wit of the later Sots art.

Komar and Melamid's next foray into Pop art consisted of a series of four paintings based on American and English Pop prototypes. These are *Post Art No. 1* (1973), an Andy Warhol tomato soup can; *Post Art No. 2* (1973), a firing machine gun by Roy Lichtenstein; *Post Art No. 3* (1973), a Robert Indiana sign motif; and *Post Art No. 4* (1973), a racing car with symbolism by Phillips—probably all culled from Western art magazines. These Pop emblems have been badly scorched and burned by the artists, then remounted on unprimed canvas. The artists rationalize that by submitting these paintings to a blowtorch they have antiqued them, providing a history for their contemporary models which, as yet, lack "biographies." There is a tangential alchemical explanation for these burned images. This is related to the firelike nature of imagery in general. Furthermore, the commercial images and icons are connected to trivial repetition, as opposed to sacrifice as a form of archetypal repetition where what is offered up of material value disappears through fire. As "Post Art" the artists are making a comment on the ultimate destiny of all art, in spite of the human craving for preservation.

Also completed in the same year, *History of Russia* (nos. 1–6), is a series of six unprimed canvases which insightfully describe the expansion of the Russian empire from a confederation of principalities in the fifteenth century through

25. Amy Newman, "The Celebrated Artists of the Second Millennium A.D.," *Art News* (April 1976), p. 43.
26. Camilla Gray, *The Russian Experiment in Art: 1863–1922* (1962; reprint ed., New York: Harry N. Abrams, New American Library, 1971), pp. 136–37.

the middle twentieth century when Joseph Stalin met with Churchill and Roosevelt to subdivide Europe into East and West blocs. In the first panel Stephan the Bearded addresses the Duma in Moscow concerning the elimination of self-government in Novgorod, May 1471. Panel 2 is an April 1552 meeting of the Duma on the most expedient way to take over the Khazan Khanate. Panel 3 deals with the Nishtadt Congress of 30 August 1721, 4:00 A.M., when various lands to the northwest were annexed to the Russian Empire. Panel 4, 10 May 1792, is concerned with the invasion of Poland under Catherine II. Panel 5 depicts a discussion about an explanation to European countries as to Russia's Siberian expansion, 19 November 1864. Panel 6 ends the progression with the Yalta Conference agreement, giving the Soviet Union political hegemony over eastern Europe. While the canvases remain the same in height, 38 inches, they continue to expand, panel by panel, from 27½ inches to 50½ inches for the last. The figures at the conference tables remain neutral, stick figures, loosely painted. While the rough, raw canvas backgrounds dwarf the figurative foregrounds, the canvas weave tends to complement and work with the tiny painted human forms. In a sense, the expanses of raw canvas are a metaphor for "Earth" or in this instance, acquired territory. This is Komar and Melamid's way of expressing the fact that imperialism is not a completely capitalistic phenomenon.

One of the more complex, early works of the pair is a series of 197 painted wood panels entitled, *Biography* (1973). Each panel or tile is only 1⅝ inches square, these are arranged almost like dominos in linear patterns with occasional right-angle diversions. Generally the panels run the gamut from comic strip drawing, poster technique, stylized realism to near photographic realism. The life story portrayed is archetypal, a synthesis of incidents and stages in the life of a young Russian intellectual.

A summary of *Biography* would be as follows:

"Into a world of guns and rallies in Red Square the 'hero' is born. His childhood is filled with games, Young Pioneer activities, school, vacations. Suddenly, his father is seized, accused as a Jew of capitalist or other crimes, and executed. The youth grows older and dreams about the future. Girls enter his life when he enters Moscow University. Long winter nights are punctuated with earnest discussions. With the coming of spring, the young man roams the city, his mind astir with sex, studies, politics, art, and more girls. The hero falls deeply in love and his girl becomes pregnant. The couple is admonished at a Komsomol meeting. The girl submits to a late abortion which causes her death. Despair engulfs the young man and he seeks solace in the country. He tries to come to terms with life and learning, the gross and the grandiose, religion and technology. To him, Russia seems dominated by militarism, even at the university, and at endless queues for standardized products; and the specter of Stalin haunts the land. The hero sets off on a solitary course, seeking the door to a new life."[27] *Biography* contains little humor but considerable pathos, being, one suspects, quite autobiographical, the chronicling of progressive disillusionment which in turn leads to a less materialistic faith. By Sots or Pop art standards *Biography* is not a particularly successful work of art for Western viewers, but with some key to the sequence of panels it remains a poignant and revealing history. The autobiographical documentation is a conceptualist genre skillfully developed by such European artists as Ben Vautier and Christian Boltanski, not forgetting Vito Acconci in the United States.

Two highly successful Sots pieces in the ideological styles of official Russian poster art are Komar and Melamid's *Double Self-Portrait* (1973) and the wordless *Don't Babble* (1974). The *Double Self-Portrait* is a 36-inch-diameter tondo done in the mosaic style often used in Soviet

27. Seiberling and Goldfarb, "A Russian Life," pp. 40–41.

public portraiture, combining the Byzantine tradition with the impression of rocklike leadership. In this case Melamid and Komar, with a mustache and goatee respectively, appear suspiciously in roles of Stalin and Lenin, with a slight smile on Komar's face indicating perhaps that communism might have its lighter moments. Around the circumference of the tondo are the words, "NACHALA 70-KH GODOV XX-GO VEKA, GOROD MOSKVA. . . . IZVESTNYE KHUDOZHNIKI [Beginning of the Seventies of the Twentieth Century, City of Moscow . . . Well-Known Artists]." Thus, in the style of Soviet patriotic plaques, Komar and Melamid are beating their own drum.

Using Soviet poster technique *Don't Babble* (1974) reveals the face of a youthful male worker with the right forefinger raised to his lips; the face is stern and somewhat classically "heroic." While explicitly the painting addressed itself to the Soviet fear of foreign agents and intelligence experts picking up loose gossip from Russian citizens, there is an implicit idea behind the words concerned with the mystery of art-making and its hidden devices. This is the artists' interior message.

One somewhat cryptical series involves the fabrication of an artist by the name of Nikolai Buchumov. A painting signed "N. Buchumov" was discovered by the artists in a trash can. Since no available information existed on such a person, Komar and Melamid invented an autobiography for Buchumov, a somewhat droll, panegyric on simple country life. The autobiography begins with the sentiment, "The life of nature, its breath fanning the body and the soul, the unhurried and majestic movement of time, this is the only theme of my work. The human bustle, petty squabbles, petty passions, little boxlike houses, towers, columns—all this defies nature, but, praise be to God, it does not affect its essence; these are only dirty specks on its body. No sooner does Mother Nature gently turn another side to the sun, than all loathsome things fall off her,

because they are superficial. And the abuse and running about of the petty people who had been quiet for awhile, the people who try to cover everything with their excrement, begins anew. Let people be damned."[28]

Buchumov goes on to describe his childhood in the village of Buslaevk during the late nineteenth century, his education, and then a journey to Moscow where he studied art at the Academy of Painting, Sculpture, and Architecture. Artistic decadence all about him, Buchumov fought with a third-year art student who accidentally knocked out his left eye. Returning to his native village in poor health Buchumov turned to farming and painting. He then fabricated sixty small-sized cardboard rectangles with the plan to make four nature studies per year. Painting from a single spot the same landscape year in and year out, Buchumov completed sixty-four studies, and since he worked with monocular vision, the right side of his nose appeared to the left in each painting—realist that he was! As time goes on, the nose lengthens and the landscape scenery shifts incrementally each year, corresponding to changes in revolutionary Russia. Given the left-right hemispheric opposition within the human brain, is there significance to the blinding of the left eye, that side connected with the digital, logical side of the brain? Is the single landscape motif a parody of Monet's serial paintings of Rouen Cathedral and the haystacks of Giverny? A failed painter in terms of the Moscow critics, a realist through and through, Buchumov ends his autobiography with the sentence, "Observing that the bundle of cardboard, which I primed in 1917, is steadily dwindling, I am not experiencing any sadness, since I know that the eternity of nature is a guarantee and pledge of my immortality."[29] Again, Komar and Melamid return to the

28. "Notes on Buchumov et al." and excerpts from "The Realism of Ideas," by Aleksandr Goldfarb, documents provided by Ronald Feldman, Fine Arts, Inc., for the February 1976 exhibition of the art of Komar and Melamid.

29. Ibid.

theme of the dissolution of art through the entropic powers of nature. What, one might ask, does that right eye see that remains invisible to those with binocular vision? Is Buchumov in reality a conceptualist?

During 7 February 1976, on and about noon New York City time, and eight o'clock at night Moscow time, twenty instrumental performers simultaneously performed *Music Writing: Passport* by Komar and Melamid. Musicians in London, Paris, Toronto, Florence, Berlin, Sydney, Stockholm, New York City, Moscow, and San Francisco, among other cities, played a score in which each letter of the Russian alphabet became a musical note, each letter was the sequence of regulations (in this case ten of more than thirty-eight) which make up the articles contained in the Soviet domestic passport. Of course playing this international concert resulted in a nonsensical melody, one without musical value, yet its artistic transcendence lay in the fact that it could be heard throughout the world. The domestic passport includes such rules as "Dispatching, mailing, or leaving the domestic passport as a deposit is forbidden," or "A stamp must be obtained for permission to leave the city of departure before certification can be obtained to enter the city of arrival," or "Repeated offenses by a citizen of the U.S.S.R. against official passport regulations will be considered a criminal offense punishable by imprisonment."[30] Musicians noted passport infringements with discordant noises. In Moscow Komar and Melamid played a taped musical version in their apartment for a small audience who were photographed by the secret police as they entered the building.

*Color Writing: Ideological Abstraction No. 1* (1974) is an earlier painting very much related to the *Music Writing: Passport* joint performance. Again, different colors were assigned to all the letters of the Russian alphabet. Then colored dots were positioned on an unprimed canvas to spell out Article 120 of the Constitution of the RSFSR (initials of Russian Soviet Federated Socialist Re-

public, the largest of the sixteen republics of the USSR). A translation of Article 129 reads:

In conformity with the interests of the working people, and for the purpose of strengthening the socialist system, the citizens of the R.S.F.S.R. shall be guaranteed by law: 1) freedom of speech; 2) freedom of the press; 3) freedom of assembly and rallies; 4) freedom of street processions and demonstrations. These rights of citizens shall be ensured by putting at the disposal of the working people and their organizations printing presses, stocks of paper, public buildings, streets, communication facilities and other material requisites for the exercise of these rights.[31]

Undoubtedly this is the most ironic "right," and the most governmentally abused right in the Soviet constitution. The irony continues with the fact that the painting *is abstract*, counter to Socialist Realism, but reveals by hiding its true contents. This particular canvas passed Soviet customs inspection as a possible tablecloth while the typescript of Article 129 was confiscated. Such a multileveled romp with the means of abstraction is all the more interesting in that it lends a political-sociological-functional orientation to Western formalist abstract art.

*Documents* (1975) is a purely conceptual piece composed of twelve rectangular plexiglass plates which represent the various sizes of official documents used by the average Soviet citizen, including a birth certificate, a travel pass, school identification, party membership, a railway ticket, and so forth. Situated directly below is a 4-inch square of red plexiglass representing the "average" size of the twelve documents—the red square becomes, in effect, a symbol of Soviet bureaucracy, resonating with its geographical counterpart in Moscow.

*Circle, Square, Triangle* (1975) represents one of the more platonic and perplexing conceptual works of the two artists. It consists of three

30. Ibid., "Translation of Ten Articles Contained in the Soviet Domestic Passport," p. 1.
31. Ibid., "Translation of Article 129 of the Constitution of the R.S.F.S.R.," p. 1.

white-painted wooden shapes, a square and a triangle each 33½ inches on a side, and a circle with a diameter of 33½ inches. The three forms are offered to the public for sale in the form of spiritual nostrums. Komar and Melamid present the geometric shapes as a basis for "each and every perishable object of comfort."[32] The artists claim that the shapes have been achieved by mathematical computations that link the moon with the human body; this is followed by a discourse on the alchemical natures of the sun and moon. Seven is the connecting integer for man, and through this and other numbers the artists arrive at the modular relation between the size of Moscow and the human soul. In a sense these forms have much to do with the twenty-first emblem or plate in Michael Maier's *Atlanta Fugiens* where the motto reads: "The Philosopher says: Make a circle out of a man and a woman, derive from it a square, and from the square a triangle; make a circle and you will have the Philosopher's stone." It is interesting that a circle mediates the angles of the sides and base of the Great Pyramid. A more modern interpretation of these basic geometric forms is the assignment of color and other traits to each shape by Kandinsky and other members of the Bauhaus at Weimar and Dessau in the 1920s. Here, again, the basis for these attributions lies more in Platonism and mysticism than in modern Gestalt theory.

The sales pitch of Komar and Melamid for these twelve ruble keys to the verities of life ends with the entreaty: "Take your choice, we can supply you, wholesale and retail, with individual eternal ideals linked a priori to nothing, manufactured from the highest quality of domestic lumber and imported cements and paints by the hands of the virginal maidens employed by the enterprise of Renowned Artists of the Twentieth Century Seventies, Moscow. A CIRCLE, A SQUARE, A TRIANGLE—for every home, for every family!"[33]

A work of art in a similar vein, Sots art in that it represents a kind of tongue-in-cheek adver-

tising, is the conceptual *Color Is a Mighty Power*, (1975). Twenty-five colored wooden panels, 1⅝ inches square, are represented with a text. Again, each colored square is advertised as a nostrum for a particular affliction; drinking problems, impotence, inferiority complexes, obesity, emaciation, insomnia, laziness, alienation, and pregnancy are all cured by staring at specific colored squares for varying lengths of time; for example, neuroses (what kind or kinds are not specified) are eliminated by gazing intently at an olive green square for five minutes and nine seconds at a time. While there is a quasi science of color therapy, it is also likely that *Color Is a Mighty Power* is a takeoff on minimalist painting esthetics. Here again, the artists tend to fuse two or three art styles into a posthistorical synthesis. Eclecticism in this instance is a kind of debunking device or means of demythification by the revelation of a pseudopractical use. Color and visual concentration through the agency of art may cure psychic maladies, but not as the kind of blatant panacea proposed by Komar and Melamid.

Perhaps the driest examples of Soviet Pop art in the 1976 exhibition are the four banners of typical agitprop slogans. In large letters painted white on red cloth, averaging about 16 inches by 76 inches, the artists have proclaimed, "Our Goal—Communism," "Glory to Labor," "Onward to the Victory of Communism," and "We Were Born to Turn Dreams into Reality," all executed in 1975. Unlike Western Pop art these banners contain no substantial distortions, no enlargement as in Roy Lichtenstein's painting, no color changes, or variations on brand-name advertising logos. In fact, the only appendage which distinguishes these banners from thousands of others throughout the Soviet Union is the small, printed addition of the artists' names in the lower right-hand corners. Even the slogans themselves, innocuous and shopworn, signal alternate meanings, rhetorical implications which point toward the internal

32. Ibid., "Circle, Square, Triangle," pp. 5–6.
33. Ibid.

contradictions of Soviet communism. Komar and Melamid may be implying that perhaps the world will eventually become Communist, but a decentralized, denationalized communism, little dreamed of by the Soviet Union's present hierarchy. This distancing from the banal is succinctly phrased by Komar, "In capitalist life, in America, you have an overproduction of things, of consumer goods. Here we have an overproduction of ideology. So your Pop Art puts a tomato soup can in a painting or on a table as a piece of bronze sculpture to look at, and our Sots art puts our mass poster art into a frame for examination."[34]

The conclusion that the future is already here and that it is intimately bound up with the past recurs again with *Scenes from the Future*, a series of three, pastoral grisaille paintings viewing the ruins of the Guggenheim Museum, Kennedy Airport, and Dallas Airport (1975). In a sense these echo the eighteenth-century Italian genre of bucolic landscapes dotted with Roman ruins. Or one could cite the panoramic landscapes and architectural scenes of the French painter Hubert Robert (1733–1808). Robert was obsessed with depicting monumental ruins with true grandeur, as Catherine the Great of Russia wittily put it, "The Revolution [of 1789] proved a blessing to Robert because it provided him with the most beautiful and freshest ruins." There is a reversal to Komar and Melamid's *Scenes from the Future* because the architectural archetypes of modernism are shown in vast decay, as if the farm scenes in the foregrounds of these paintings herald a new Dark Age. And to a degree, the grisaille paint tones give the works photographic veracity.

*Questions New York Moscow New York Moscow* was a collaborative performance, photographically documented, which was conceived by the journalist Douglas Davis in November 1975 and finished the following year. The work involves a collaboration between Komar and Melamid on one hand, and Douglas Davis on the other. The parties, situated in Moscow and New York City, were designated by Davis to paint a black line vertically on their respective white walls, the line approximately three inches wide. Davis then stipulated that a series of four questions were to be asked, with sign cards of the questions in Russian going to New York and English sign cards to be used in Moscow. Photographs of opposite sides of the line are to be taken with Komar and Melamid on the left side and Davis on the right. These were taken during four specific days of the year: January 1, May 1, July 4, and November 7. On the first of January, Davis initiated the question, "Where is the line between us?" On May 1 the Moscow artists responded with, "Why is the line between us?" On July 4, Davis replied with, "What is the line between us?" And on November 7, from Moscow came the retort, "What is beyond the line?"

The resulting photographs were exchanged and juxtaposed in a photomontage so that the black lines on both sides of the Atlantic became one line. The lines remain static and central in each photomontage, but through the sequence of four adjoined photographs the participants appear progressively more animated. With question four, "What is beyond the line?" Komar and Davis reach over the line so that their hands are superimposed on the walls in New York and Moscow. The line symbolizes all the political, cultural, temporal, and spatial differences separating the two superpowers. For the Soviet artists *Questions* represents "the first work of art détente." Quite apparently, it is the bravado and suggested proximity of *Questions* which psychically separates it from the smiling but stiff and emotionless poses that American and Soviet leaders ritualistically endure at summit conferences. Geographically, if not verbally, the artists have cut through international protocol and press releases to ask the simple human questions which remain trivial to the superstates.

34. Diana Loercher, "From Hearsay to Exhibition outside the Iron Curtain," *Christian Science Monitor*, 1 March 1976.

## The Komar/Melamid Exhibition, New York, 1977

For New York it would be difficult to classify the first Komar/Melamid exhibition at Feldman Galleries as a *succès de scandale*. Although if it had been allowed to happen in the Soviet Union, that very well might have been true among large segments of the population. In New York City where critical tempers are more jaded the 1976 exhibition was received with warmth and respect for the courage of the artists, plus considerable admiration for their brand of political humor. That something as bold, impudent, and satirical *could* come out of Communist Russia was a surprise to many Americans. American artists with strong leftist or liberal sentiments generally sympathized with the position of Komar and Melamid. With few exceptions politically oriented conceptual art in the United States tends to be dismally tedious, if not pretentiously concerned with its own rectitude. In comparison Sots art is a breath of fresh air.

The second New York exhibition of the two artists opened on 14 May 1977 at the Ronald Feldman Gallery. Some of the work was smuggled out of the Soviet Union, but many of the pieces, particularly the constructions and graphic works, were fabricated from plans sent to the United States. One of the few historical pastiches in this exhibition is a large vertical oil painting done in the style of the seventeenth-century, neoclassical French school, *Factory for the Production of Blue Smoke* (1975). This landscape reveals the winding terrain so familiar to the Arcadian scenes constructed by Nicolas Poussin and later Claude Lorrain, and like Claude's compositions, *Factory* is set at the end of a funneling perspective where various trees and rock outcroppings mark the eye's passage toward the horizon line. In the middle-ground the artists have placed the ruins of a Greek Doric temple. Constructed of what appears to be white marble, the temple or factory is flanked on its left by a tall column belching forth robin's egg blue smoke. Given the traditional umber glazes covering this Claude-like painting, the mushroom of blue smoke stands out in startling contrast. To the right foreground the nude figures of Komar and Melamid stand holding a large scroll inscribed with the words in Russian, "Factory for the Production of Blue Smoke."

The artists have also taken the liberty of sending letters to three of the world's leaders—Mr. Karamanlis, prime minister of Greece; Sheik Yamani, minister of petroleum and mineral resources for Saudi Arabia; and the Italian industrialist, Agnelli—generally asking for financial support in the construction of the factory for the production of blue smoke. This plea for a return to the Golden Age calls for a blue smoke unpolluted with the ideas of utilitarianism. The artists add: "We do not suggest the elimination of the colossal machinery of modern industrial production. However, it is within our power to direct this machinery along the path of eternal and ideal aesthetics. Therefore, we appeal to you, Mr. Prime Minister, and also, in other letters, to the large-scale capitalists of our time, with the request to support the construction of the Factory for the Production of Blue Smoke. We ask you to offer the land of ancient Hellas as an honored site for this Factory."[35]

What might be the significance of this "blue smoke"? If one examines the murky tan-gray consistency in the painting of this Claude-like sky, it resembles the consistency of the air in any large industrial city, say Gary, Indiana, or Los Angeles, California. So in essence the "blue smoke" is a silhouette, an absence of smog on one level. Beyond that, a partiality for blue smoke is a veiled reference to mercy, compassion, and perhaps the Holy Spirit.

One completely enigmatic work is entitled *Scroll* (1975), a wall-hanging on heavy tan canvas which is offered as a biography of the artists in the Aruoist language, a unique tongue-in-cheek

35. Copies of the letters to the respective parties by Ronald Feldman Fine Arts, Inc., for the May 1977 exhibition of the art of Komar and Melamid.

alphabet devised by the two artists. Little can be said about this work since the artists provide no obvious key to its content.

Komar and Melamid have constructed a set of paintings which they term the *Cut-Off Corner Series*. Their rationale for these is the statement, "This series demonstrates the right of the artist to an anti-individual style. The cut-off corner is 'we' or our position with respect to the history of Art." With each canvas approximately three inches has been cut off the upper left-hand corner forming a precise forty-five-degree diagonal. One iconographic interpretation of this indexical sign may be that it represents the absence of the male spiritual light, since the rays of God's creative power usually shine down from the upper-left corner in pre-Renaissance and Renaissance paintings.

Again, in baroque style with dark overglazing the artists have produced a *Double Self-Portrait* (1975–76) in which they appear in sixteenth-century costumes. Both hold a red cloth, a kind of veil, at waist height. Using a mannerist gesture, Komar points toward the lower right-hand corner of the painting, as if signifying the meaning of the cut-off corner above. The veil or opaque wall-hanging is a common device in both religious and secular paintings in the West. A few examples of its use include Nicolas Poussin's *The Eucharist* (1647), Jacques-Louis David's *The Lictors Bringing Brutus the Bodies of His Sons* (1789), or the renowned portrait of *Madame Recamier* (1802) by Baron Gerard, David's student. The curtain or "veils of the Temple" is a symbol which harkens back to the division of the Jewish Tabernacle in terms of the levels of revelation, playing a major role in the Christian mysteries beginning with the Gnostic text, *Pistis Sophia*. The rending or tearing of the veils likewise signifies a penetration of a mystery or an arcanum of sacred importance. That its color is red may be the artists' inference that the veil and its secret contain a paradox.

Also in the *Cut-Off Corner Series* is a large drip painting entitled *Chemical Reaction* (1975–76). This is in the style of radical abstract expressionism or stain painting as practiced by Helen Frankenthaler or Paul Jenkins at certain periods in their development, rather than Jackson Pollock. The pigments are essentially solutions of chemicals allowed to merge, neutralize, or react with one another. Scribbled in pencil among the chemical reactions are the formulae corresponding to the solutions themselves. The technique of a visual index reinforced or supplemented by writing is one often used by conceptualists such as Ben Vautier, Arakawa, or George Brecht. In a sense *Chemical Reaction* is a potshot at the mindlessness of much Western anti-formalism, such humor having its popularity on both sides of the Atlantic. In 1960 the Soviet humor magazine *Krokodil* published a cartoon of a painter, balanced on his hands, throwing buckets of liquid paint on a large canvas, using his feet. The caption for this cartoon was "Pure Art." Komar and Melamid's spoof, however, is far more subtle because it deals with art in terms of its historical and internal progression.

*Not Yet Too Late* (1975–76) also belongs to this series. Situated on a nearly square canvas with an intense blue background is the tiny image of a horizontal human body painted in red, with a black buzzard or vulture perched upon it. Above is a white bird in flight. Beneath the blue ground in low relief are subtle layers of Cyrillic letters, repeated, and generating outwards in six directions from an hexagonal center. These letters read, "ESHCHE NE POZDNO," or "Not Yet Too Late." A superficial alchemical explanation of this work suggests that the red figure is the mutable body of man, and the blackbird perched on the body is a symbol of decay and putrifaction, while the bird in flight is perhaps a dove signifying the Holy Spirit. Here again the state of man is allied to the condition of contemporary art and esthetics.

Next in the series Komar and Melamid present a canvas entitled *KGB* (1975–76). The KGB, of

course, is the Soviet secret police, or *Komitet Gosudarstvennoi Bezopasnosti* (The Committee of State Security) which is entrusted with surveiling such dissidents as these two artists. The letters are formed so that they run into one another, creating figure-ground conflicts between the black and white; the black strokes push toward the edge of the painting, producing a sense of crowding or overexpansion. The relation between figure and boundary is one of extreme constriction and repression.

A small work on paper, just 6½ by 8½ inches, mounted under canvas matboard and gold-leaf frame, is the didactic *Reproduction from a Picture on a Subject from Russian History* (1975–76). The scene depicted appears to be eighteenth or nineteenth century, but not identifiable in terms of its relation to Russian history by any of the scholars consulted by this writer. Briefly, this is an emotionally intense portrayal of a young peasant woman being attacked, possibly raped, by three middle-aged to elderly males. The one most prominent on the right holds a dangerous-looking halberd in his left hand and proceeds to lift the skirts of the young woman. In a niche in the upper left-hand corner of the reproduction there is a Russian-Byzantine icon and a votive lamp. While the crime or violation here appears to be of a sexual nature, one might conjecture that this represents some desecration, possibly an act of profanation against the Holy Spirit by the Russian Imperial State or the Soviet Union.

The last of the *Cut-Off Corner Series* is a square canvas (39¼ by 39¼ inches) which remains listed as *Untitled* (1976–77). Painted with oils and acrylic paint on canvas, it is an essentially mat black painting inflected by the cut-off corner and a tiny yellow dot near the middle but positioned one-third of the way from the right-hand edge. Conceivably the yellow dot has golden mean or other proportional significance, yet this is not specified. Superficially the painting resembles one of Ad Reinhardt's *Black Painting* series. But here, if there is an optical intention, it is completely different than the reasoning behind Reinhardt's subliminal cruciforms. One might conjecture that there is a symbolic connection between the missing corner and the tiny dot of yellow which may be read as "light."

*Prophet Obadiah* (1976) is a series of seven photographed panels representing the printed Hebrew version of the Book of Obadiah as it appears in the Old Testament of the Bible. Without altering the holy canonic text, the artists have expressed the changes in the tonal image of the Bible under different reading conditions— morning, day, evening, and artificial lights of different intensity. The progression of panels moves toward the right from darkest to lightest. Obadiah is the shortest book in the Old Testament, consisting of a single chapter and twenty-one verses. The Prophet Obadiah whose vision is a vindication of the people of Israel at the hands of the Edomites is largely unknown as to source, since a dozen biblical Obadiahs are mentioned. Obadiah was one of the twelve Minor Prophets of the Old Testament, the name meaning "Servant of Yahweh." The text itself is considered to be badly corrupted, merging with the Book of Jeremiah, though essentially a collection of anonymous prophecies.

Historically some light can be shed on the prophecies, but even the dating of these varies enormously from the seventh century B.C. to the second century B.C. The region which was Edom lies south of the Dead Sea, a fertile land conquered by the Edomites from a more primitive people. After the eighth century, conquest of Edom by the Jews was considered necessary for the stabilization and protection of the Hebrew monarchy. And although the Edomites had strong blood relations with the Jews, they constantly resisted Jewish subjugation and in turn were prominent in the attacks on Jerusalem before the final fall of that city. But by 127 B.C. the Jews subdued Edom and converted its inhabitants. So

the two peoples maintained a long history of hatred and distrust.

The Book of Obadiah is a disconnected set of prophecies directed against Edom, setting forth the excessive pride and self-confidence of Edom, its hostilities against the Jews, and its ultimately deserved downfall at the hands of not only the Hebrew nation but through its allies as well. Perhaps as an allusion to Russia, Edom did occupy the Seir Mountain ridge, red in color, and its people were reputed to "live between the rocks." But the parallels between Komar and Melamid as Jewish dissidents in a nation officially hostile to their art, and the comparison between ancient Edom and the Soviet Union, suggest that this work is a latter-day biblical prophecy concerning the fate of Russia. Again, this is speculation, yet it seems possible that the scriptural page photographed under seven different light intensities represents a cycle of stages in the downfall of Edom, that is, the Soviet Union.

Under the sunburst logo of KOMARMELAMID the two artists have produced a set of five black and white posters (1976). These consist of photomontages accompanied by more or less cryptic statements. The first, used as an exhibition announcement, reads, "If You Believe in Anything, Believe in Us! We Think of You!" Komar and Melamid are shown back to back, each pressing extended fingers to their foreheads in rapt concentration. In this instance there are interlocking visual and verbal puns, partly aimed at the idea of a conceivable god embedded in duality and its counterpart an unthinkable deity shielded by the nonnotion of nothingness. These conceptions of the deity relate to the neural mechanics of self-consciousness.

Another poster reads "Attention: The New Light Stations of Komar/Melamid is to Start Its Transmissions through a Broad Spectrum of Visible Light Waves. Programs are Transmitted Daily from 7 P.M. to 9 P.M., Included Will be a Lightimprovisation by Komar/Melamid on Various Contemporary Topics Concerning the Life of Mankind. We Transmit from Moscow, Leninsky Prospekt, House No. 70, out the Window on the Extreme Left, Eighth Floor." Situated beneath the copy is a nighttime photograph of the apartment house, revealing evidences of an extremely bright light source from the specified location. The essence of this message is metaphorical, namely, if art and life are "light" in the scriptural sense, then Komar and Melamid are generating light. Tied to the mystique of light as a spiritual transducer, the artists make certain numerological allusions through the time and place of transmission.

The poster reading, "On Sundays Komar/Melamid Sew Red Shorts for the Poorest Inhabitants of This Globe" is equally enigmatic, revealing below a global world map encircled by a pair of red shorts. Only the Southern Hemisphere of this globe is covered by the shorts, suggesting perhaps that world poverty mainly exists below the equator? The red shorts themselves are ambiguous, on one hand they imply Communist aid to the third world, on the other hand these are the most intimate "garments of light," that is the artifacts of art making according to Western esoteric traditions.

A fourth poster combines a photomontage with a line drawing revealing people on a bed having sexual intercourse. The caption above reads, "Ideal Apparatus of Komar/Melamid Solving Personal Energy Problems." Connecting the photomontage and its duplicate line drawing is a drawing of a wet cell battery with positive and negative terminals. The poster presents a possible ambiguity in that the charging of the battery can be due to the discharge of sexual activity, or it can be due to the generation of energy through the motion of the bed. The artists suggest some kind of hidden reciprocity between sexual release and the transformation of mechanical energy into electrical energy, as if this had something to do with art making as well.

Komar and Melamid's last poster reveals a sealed, unlabeled tin can with the caption, "Excre-

ments of Komar/Melamid on the Fields of Under-developed Countries." No doubt the export of nitrates and other chemical fertilizers is an important source of aid to underdeveloped countries by both communist and capitalist nations. The poster alludes to this meaning, but it also suggests Marcel Duchamp's famous equation between art and excrement. Prior to Komar and Melamid's poster, in 1961 the Italian artist Piero Manzoni created an edition of cans labeled "Artist's Shit." However the Russians' can of excrement is meant not so much as a flagrant object d'art as it implies a source of conceptual fertilization.

In line with the artists' statement that in the United States there is an overproduction of consumer goods while the Soviet Union manufactures excessive ideology, Komar and Melamid have made a series of thirty-six 8-by-10-inch color photographs, each with text and entitled, *A Catalogue of Superobjects—Supercomfort for Superpeople* (late 1976). In part, this project grew out of various department store catalogues sent to the artists by friends in New York City. In the Soviet Union luxurious specialty stores filled with objects for "the man who has everything" are nonexistent. Thus, Bloomingdale's or Hammacher-Schlemmer remain intriguing fantasy lands for the two artists.

In a preface Komar and Melamid proclaim that "The Socialization of the Modern World is a reality." They go on to speak of the progressive destruction of the social hierarchy which inhabited Europe from classical times onward. "By trying to be like everyone else, the ruling class has obliterated the elite and the intellectual divide between it and the masses. The result is the mindless, semi-literate, economic and cultural policy of the governments of Europe. Contempt for ancestral traditions coupled with appeasement of every form of modernism has undermined the foundations of this world and will lead to its total destruction."[36]

The catalogue of "Superobjects" has been de-signed for what the artists term, with tongue in cheek, the "New Aristocracy." The origin of these lavish products are, according to the artists, "the principles of Ideological Design," and their destination is the "Ruling Elite." Again the artists present us with a double-edged sword. Superficially these appear to be toys and decorative accessories for the leisure class, but underlying their glitter are usually thoughts with a spiritual message, indeed vague at times.

In the first series designated *Prestigeants*, there is *Stong* a high metallic collar and chin support attached to a rigid back brace: "It sounds Proud! Revive your self-esteem! Stong-II inculates inflexible truthfulness, breaks the humiliating habit of flattering and fawning before the powerful of this world. It develops a charming, stately posture—guaranteed to provoke amorous responses from those around you. Made of Ebony and Gold. A sliding-collar system means Stong-II will fit different heights and builds."[37]

*Spirit* is represented by a yellow gloved hand, but the glove in this instance has neither fingers nor an opposable thumb. *Spirit* is a kind of extended sleeve sewn off at the end, a possible prevention of onanism. "The Dungeon of the Five Sinners! Many ills of contemporary life can be traced to the uncontrolled behavior of our Five Fingers. Stop the sin of your slave hands! Punish them for misconduct and limit their freedom by strapping the thumb opposite the other four fingers. Your hand takes on the oneness of the hoof of a triumphal horse—Conqueror of vile desires."[38]

Quite likely the most complex work in this exhibition is the creation of a unique form of internationalism, *TransState*, a loosely organized category of "state-individuals" or "I-States." Not unlike the fiat of Louis XIV, the fundamental law

36. Supporting documents for *A Catalogue of Superobjects —Supercomfort for Superpeople*, supplied by Ronald Feldman Fine Arts, Inc., for the May 1977 exhibition.
37. Ibid., No. 3.
38. Ibid., No. 12.

of TransState is "L'etat, c'est moi." Komar and Melamid have typed up a lengthy (five legal pages) Provisional Constitution for their new state, with themselves as the two governing consuls, with unlimited powers, for a term of one year. New consuls are voted in annually and the old consuls are free to join the federation. The provisions for TransState follow in abbreviated form those set out for any sovereign nation. The internal degree of democracy attained by its citizens may be ambiguously interpreted. However, citizenship to TransState seems to be open to any person in the world who manifests dissatisfaction with his own country. In fact, it is the rigid, monolithic consistency of nation-states which frustrates the artists, "The primitive and historically transient content of the content of 'Nation' is in the best cases, the most profound misconception of our contemporaries and, in the worst, the ill-conceived covenant of the forces of world reaction. It is the single obstacle preventing the United Nations from fulfilling its lofty function of regulating mankind's international disputes."[39]

The artists view the national-state as we know it as "a prison of personalities contained within unnatural boundaries"—to be succinct, the thrust of TransState is the creation of world anarchy, that is the *absence* of authority as defined through hierarchical structures. Rather than seeing the state as a monolithic reality, Komar and Melamid view it in its prototypal form as a quasi-contractual agreement between human beings, one which all too often appears to be an anachronism. With justified cynicism they tend to view both capitalist and Socialist states as stultifying, centralized systems, more wedded to bureaucratic tyranny than to human rights. Besides their constitution, the two have constructed a signpost which points in four directions and reads "TransState" in each direction. Quite possibly they are implying that TransState is nothing less than a state of mind.

The final work in the exhibition, *Farewell to Russia* (1977), is one of the most difficult to analyze because of its magical intentions. This is a fabricated documentation of the artists performing a "black magic ritual" using "documentary photoimages."[40] Feldman Gallery constructed the work from directions in Russian which are not always clear, but the American dealer was asked to have a photograph and sound cassette tape reproduced eighteen times. The photograph reveals the artists involved in ritualized activity with an ax and long needle in firelight. Their objective is the Russian spirit. Each of the photographs is mounted on a smooth, lacquered, wooden plaque made according to the intentions of the artists, to simulate icons. These surfaces are hacked with the ax and each of the photographs has an eighth-of-an-inch-in-diameter knitting needle projected about six inches or so through its center, point forward. The eighteen copies of the cassette have been superimposed on a master tape and played as a chanted ritual. At the time, the artists gave the gallery instructions not to release the text of the chant while they were still in Moscow.

The chant, which is sixty-two lines, is intense and bloodthirsty, it asks for nothing less than the total physical destruction of Russia, or does it refer to the malevolent spirit within contemporary Russia? One could look at this as a form of exorcism where the goal is to free the souls of Komar and Melamid from the pull of Russia so that they can face the world beyond Russia as physically free men. Nevertheless, this work of theirs contains less mirth and more hateful desperation than any other. If this is the pair's swan song to Russia, it is meant to be irrevocable, and is.

39.  A supplementary document to the "Provisional Constitution of TransState," entitled "Address of the Consuls of TransState to the United Nations," 14 May 1977, supplied by Ronald Feldman Fine Arts, Inc., for the May 1977 exhibition.

40.  An English translation of the artists' letter to Ronald Feldman has been supplied by the gallery. This provides directions for making *Farewell to Russia* and a transcript of the magic incantations accompanying the ritual.

## A Western Overview of Komar/Melamid

One of the primary distinctive traits of Western art is its lack of ubiquity. In Communist and capitalist countries this means tight selective and financial control exerted over its distribution. During the twentieth century the economic and esthetic rationale for this control has been gradually subverted and increasingly questioned. Critics as well as artists are participating in this process. Possibly more than other contemporary artists in the Soviet Union, dissident or official, Komar and Melamid have chosen to question not only the internal policies of their own country, but the precepts of "modernism" and of art itself as a socially supported cultural activity.

In this they are not alone. Understandably considerable criticism in the West stems from Marxist or neo-Marxist artists and critics. Recently in the United States such art journals as *Fox*, *October*, *Left Curve*, and *Red Herring*, short-lived as some of these magazines have been, have asked extremely penetrating questions, not only about prevailing stylistic trends, but about the uses of art in corporate and U.S. State Department policy, the financial underpinnings of museums, the emerging symbioses between critics, curators, and commercial galleries, and the issue of art historical methodology as a form of cultural elitism. Their goals have been mainly polemical and political, often the results of frustration experienced as artists involved in conceptual or performance art. With the appearance of alternative art periodicals it becomes increasingly apparent how much the major commercial art journals are tied to the official gallery and museum hierarchy.

In a sense there is as much a "right" and "left" to the Western art world as there is in the Soviet Union with its Artists Union and Ministry of Culture. An art editor such as Vladislav Zimenko maintains an ideological position in the Soviet Union which is not too far removed from the function served in the United States by such guardians of "good art" as Hilton Kramer or Clement Greenberg. Tom Wolfe's irreverent *The Painted Word*, a polemical essay attacking late formalist criticism and the doctrine of "flatness" in painting, did as much to jar the underpinnings of the art establishment here as the abstractionists did in Moscow during the early 1960s in attacking the hegemony of Socialist Realism.[41] Unlike Europe, there is little political art in the United States. In artistic sophistication only the German-born artist Hans Haacke rivals the political effectiveness of Komar and Melamid. In terms of humorous subversion only the Irish-born artist Les Levine approximates the style of Komar and Melamid. Large-scale documentaries such as Levine's "The Troubles," "Last Book of Life," and "What Can the Federal Government Do for You?" are as insightful into the philosophies of Northern Ireland or the United States government as the art of the two Russians is to the Soviet Union. In West Germany and France political art tends to be ironic and severely to the point, it has none of the tomfoolery that characterizes Komar and Melamid's method, or Levine's. As with the two Soviet dissidents, there is a strong spiritual dimension to the art and writings of Joseph Beuys. It is this spiritual property which allows Komar and Melamid's art to rise above ideology or internal Soviet policy.

One might properly ask if Komar and Melamid are in danger of being used as propagandistic pawns by the United States (since news of the 1976 New York exhibition was broadcast to Russia by Radio Free Europe and the Voice of America), or if they care if this happens? According to one report, this created some notoriety for them among the young counterculture of Moscow. And if their goal is that of gaining exit from the Soviet Union, perhaps international publicity is the best expedient. After their dismissal from the junior division of the Artists Union the two

41.  Tom Wolfe, *The Painted Word* (New York: Farrar, Straus, and Giroux, 1975). Originally published in *Harper's*, April 1975.

joined the Soviet Union of Graphic Artists, but were expelled from this when they applied last year for exit visas. According to Aleksandr Goldfarb a significant schism developed between the members of the Union of Graphic Artists when the vote was taken to banish the two. "During a heated discussion," Goldfarb said, "many spoke in their favor, which was unusual. In the end, of the 60 members present, 28 voted for their expulsion, 15 against, and the rest abstained—quite unprecedented in Russia."[42]

Even if the ideological tides are running in favor of Komar and Melamid, one can not help but wonder what their fate might be in the West. If art is a matter of historical accident, of doing the right thing at the correct time and place, then what is the artistic future of Komar and Melamid if they are deprived of the abrasion and suppression of Soviet dogma? The concept of a vanguard "cutting edge" in art is meaningless if the knife is deprived of its cuttable material. In any event, there is every likelihood that their survival as artists outside the Soviet Union will be the true test of their art as art.

42.  Glueck, "Dissidence as a Way of Art."

Komar/Melamid                    Soviet Dissident Art

**Quotation**

1972, oil on canvas, 31″ × 46½″.
Collection of Frayda and Ronald Feldman.
Photograph by eeva-inkeri

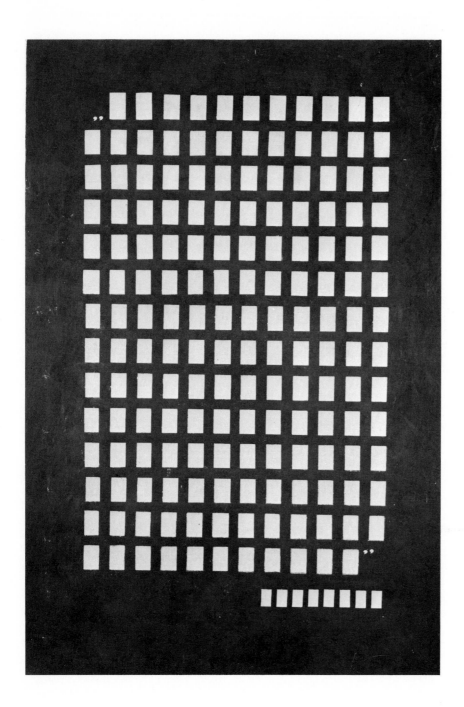

**Laika Cigarette Box**

1972, oil on canvas, 23″ × 30½″.
Collection of Gian L. Polidoro.
Photograph by eevi-inkeri

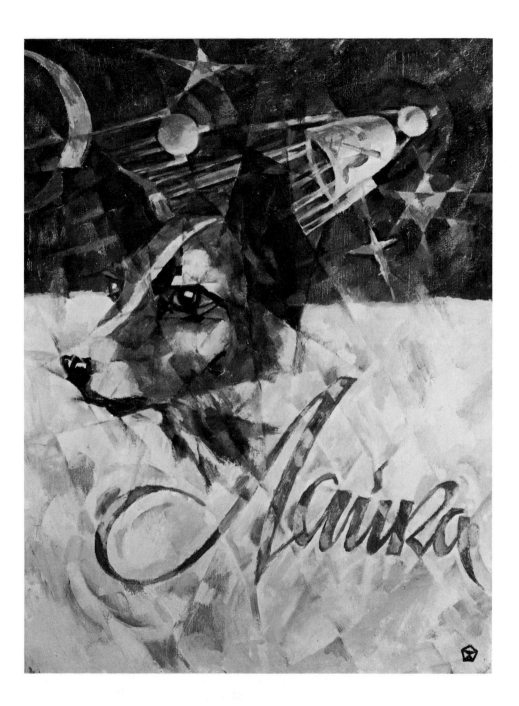

**Meeting between Solzhenitsyn and Böll at Rostropovich's Country House**

1972, oil and collage on canvas.
Collection of Bob and Maryse Boxer

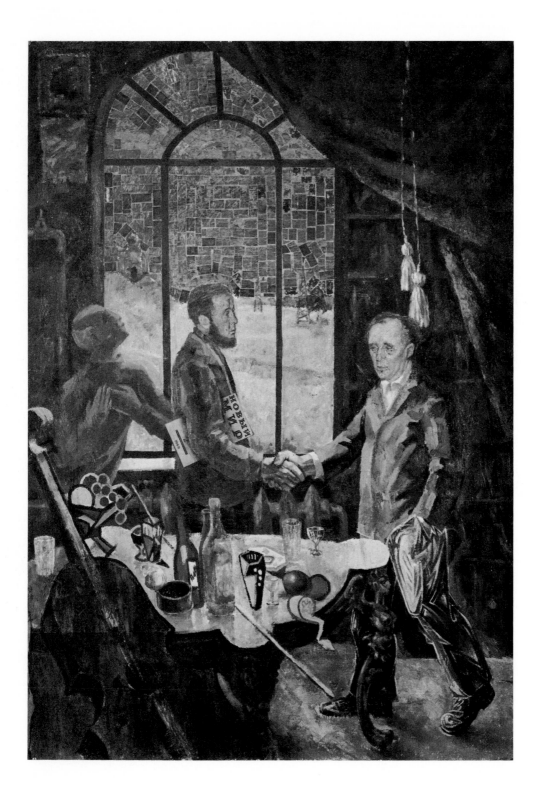

**Don't Babble**

1974, oil on canvas, 24″ × 35½″.
Collection of Muriel Karasik.
Photograph by eeva-inkeri

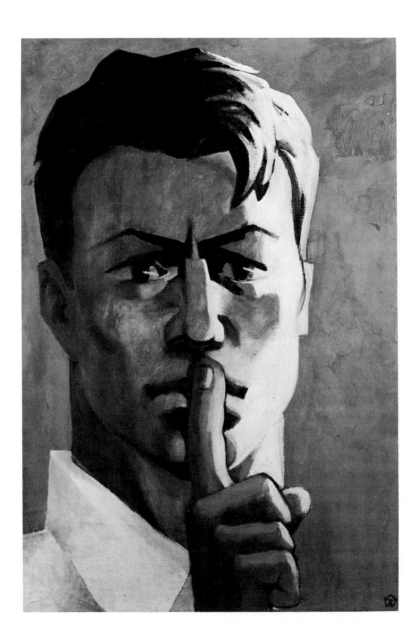

**Double Self-Portrait**

1973, oil on canvas, diameter 36″.
Collection of Melvyn B. Nathanson.
Photograph by eeva-inkeri

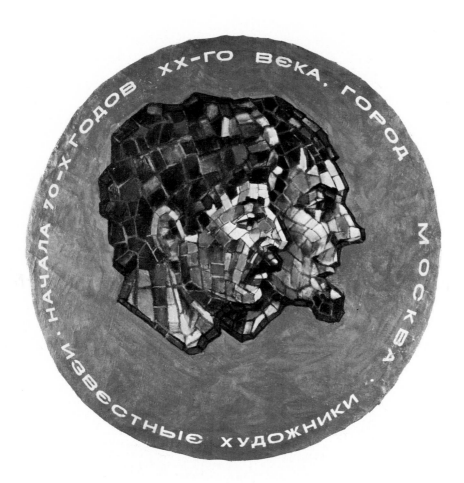

**Post Art No. 1**

(Warhol), 1973, oil on canvas, 42″ × 42″.
Collection of Frayda and Ronald Feldman.
Photograph by eeva-inkeri

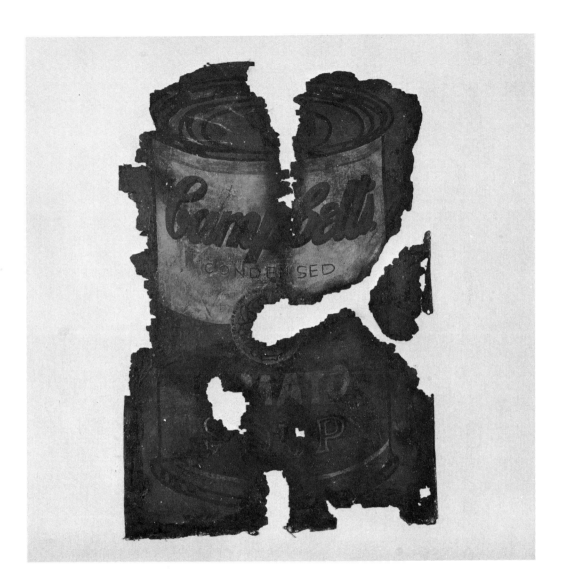

**Post Art No. 2**

(Lichtenstein), 1973, oil on canvas, 42″ × 42″.
Collection of Bob and Maryse Boxer.
Photograph by eeva-inkeri

**Post Art No. 3**

(Indiana), 1973, oil on canvas, 42″ × 42″.
Collection of Bob and Maryse Boxer.
Photograph by eeva-inkeri

**History of Russia**

1973, oil on canvas, six panels,
Collection of Bob and Maryse Boxer.
Photographs by eeva-inkeri

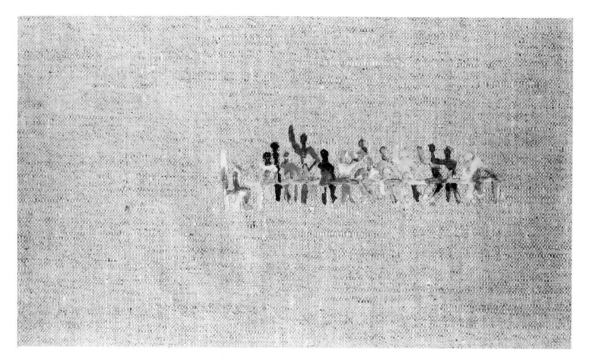

No. 1 of six panels, 38″ × 27½″, detail

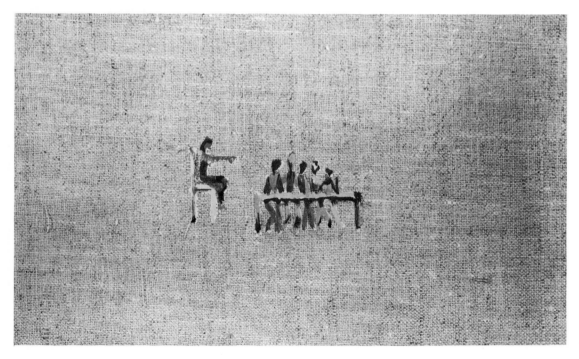

No. 4 of six panels, 38″ × 42½″, detail

No. 5 of six panels, 38″ × 47″, detail

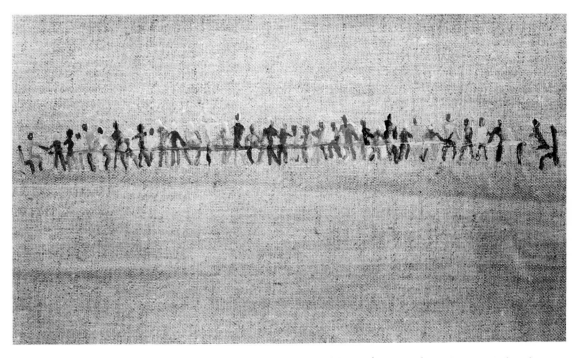

No. 6 of six panels, 38″ × 50½″, detail

# Autobiography

**Nikolai Buchumov**

The life of nature, its breath fanning the body and the soul, the unhurried and majestic movement of time, this is the only theme of my work. The human bustle, petty squabbles, petty passions, little boxlike houses, towers, columns—all this defiles nature, but, praise be to God, it does not affect its essence; these are only dirty specks on its body. No sooner does Mother Nature gently turn another side to the sun, than all loathsome things fall off from her, because they are superficial. And the abuse and running about of the petty people who had been quiet for a while, the people who try to cover everything with their excrement, begins anew. Let people be damned.

One must live so that nothing remains in man that is human, but only that which relates and blends with nature. Be a tree, river, grass, sky, part of the earth, and then you will be clean and light, as clean and light as a tree, river, grass, and sky.

I was born in the village of Buslaevk, Penza province in 1891. The sexton of the parish church of the Holy Nikolai registered me on the instigation of my Grandmother Frosia, the sister-in-law of my mother's father, as Khariton. My deceased parents and all good people called me Nikolai. I do not remember my parents; I only remember the sharp odor of wormwood, its smell mixed up with something sweet and good—what it was I do not know to this day. I also remember that in the entranceway there was a wooden trough, which I often kicked with my feet, and it gave out such a wondrous peal, so that to this day at the sound of bare feet against a trough there arises in my spirit a feeling that I cannot put into human speech. My Grandmother Frosia, with whom I spent my entire youth, used to give me a good hiding when she got angry, because of my passion to cover the stove with drawings in ashes, so that to this day in bad weather my kidneys do not let me fall asleep. In these dreamless nights I decided to put on paper my life and thoughts, which have arisen over more than twenty years' work with my brushes.

At the age of twelve, I ran away from my grandmother to the city of Penza, where at first, I had to steal; but then a good man, Petukhov, an undeservedly forgotten portraitist, a graduate of the Moscow School of Painting, Sculpture, and Architecture, treated me, an orphan, kindly and gave me my initial knowledge of the modeling of a head, perspective, and other secrets of our wonderful profession. I used to work then about ten–twelve hours a day, and felt as though my head were buried in fragrant straw.

During my tenth year there, with money given me by Petukhov, I went to Moscow, where I was stunned by the noise and the commotion, which I began to hate from that moment on all my life. And, on the whole, the Moscow period is the stupidest part of my life. Having passed the entrance exams, I studied in the School of Painting, Sculpture, and Architecture, but with the professors—vain and empty people thinking only of earthly and base goods such as prizes, exhibitions, and grants—I agreed with them neither in my ideas nor in my work, for which they revenged themselves on me with bad marks. I did not agree with the students for the same reasons. My reserve was especially strained, when in an argument about art, a decadent (the third-year student Ptsel'nikov) accidentally knocked out my left eye with his fist. Lying in the hospital, I thought about many things and immediately upon my release painted the picture *In the Sea*. I can see it vividly—it is poor because it is decadent, and therefore it is not sincere, not real, though it has some features of genuine work. It was shown at the student exhibition. Harshly hostile reviews and mockery rained down on me, and for this reason, also because of my shaken health, connected with my kidney ailment, I returned to Buslaevk.

It was the summer of 1913. The smells and colors of my native village enveloped me, and I vowed never to forsake it, no matter what would happen. I lived in the cottage of my grandmother, who soon died, so I began to fend for myself. I became a plower, hay mower, reaper, and so on. I was a little acquainted with these village professions even before, but now I came to master them in earnest. I decided for a time not to involve myself in painting but to look around and decide what to do and how to do it, to put together a plan and gradually carry it out. My musings over this plan took me three and a half years, after which in 1917 I primed, in a special way devised by myself, sixty pieces of cardboard about the size of my palm, four for each year, having figured out that I had no more than fifteen years left to live, considering my damaged kidneys. According to my plan, I decided to do four studies a year, one study for each time of year.

I prepared my brushes myself. A marble board, which formerly held a clock, carefully preserved by me, a gift of my late benefactor Petukhov, has faithfully served me until now. On it I rubbed in the juices of every manifestation of nature. In this connection, I would like to add that in the rubbings mixed with oil, each earthly creature gives its own color. I am painting from a single spot, where, as they say, my late mother gave birth to me while working in the fields. Here, I hope, they will bury me.

Now it is already 1929 and if God gives me four more years, I will be able to fully carry out my project: to create the epopee of my life, dissolved as an insignificant part into the immense expanse of my homeland. Observing that the bundle of cardboard, which I primed in 1917, is steadily dwindling, I am not experiencing any sadness, since I know that the eternity of nature is a guarantee and pledge of my immortality.

*The village of Buslaevk*
*12 April 1929*

**N. Buchumov, 1917**　　　　　　　　　　1973, oil on canvas, 20″ × 43½″.
Collection of Melvyn B. Nathanson.
Photograph by Francis Olschafskie

**N. Buchumov, 1917**　　　　　　　　　　1973, oil on cardboard, 6¾″ × 4¾″.
Collection of Melvyn B. Nathanson.
Photograph by Francis Olschafskie

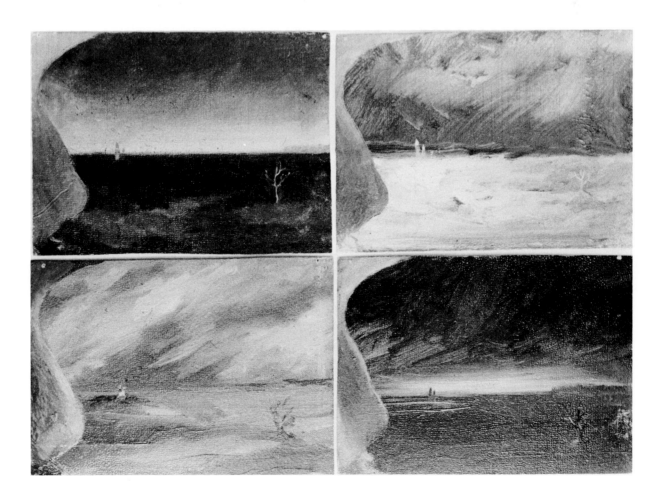

**Biography**

1973, paint on wood squares, 197 squares, each 1⅝".
Collection of Bob and Maryse Boxer.
Photographs by eeva-inkeri

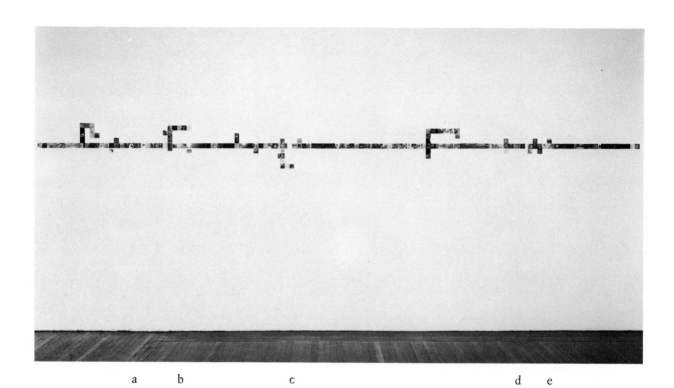

a      b           c                    d    e

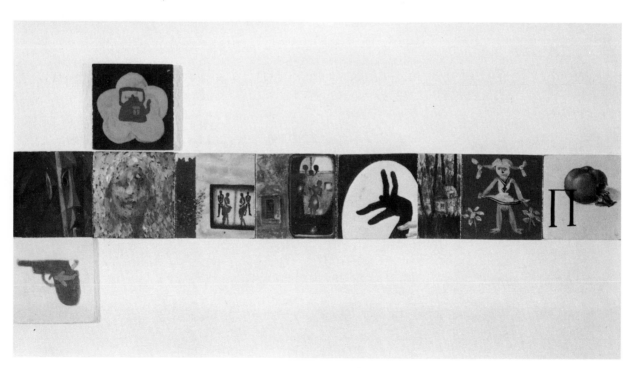

Detail a

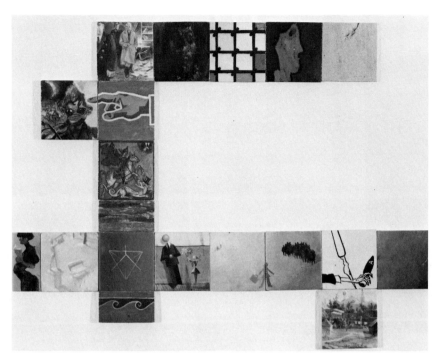

Detail b

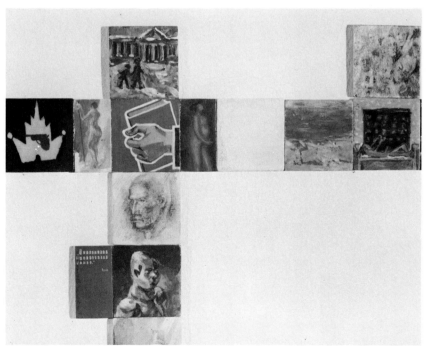

Detail c

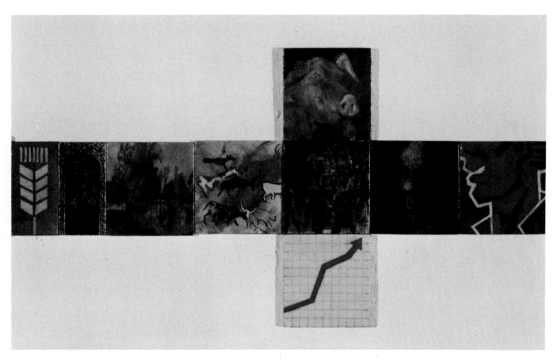

Detail d

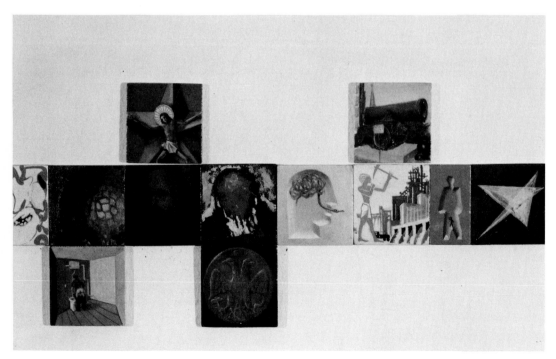

Detail e

**Color Writing: Ideological Abstraction, No. 1**     1974, oil on canvas, 83″ × 39″.
Collection of Frayda and Ronald Feldman.
Photograph by eeva-inkeri

**Documents**                    1975, photograph

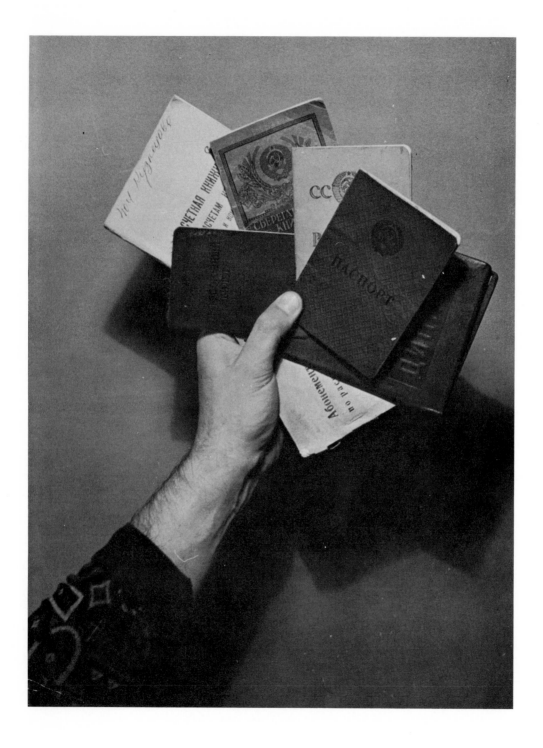

**Documents**                                    1975, photograph

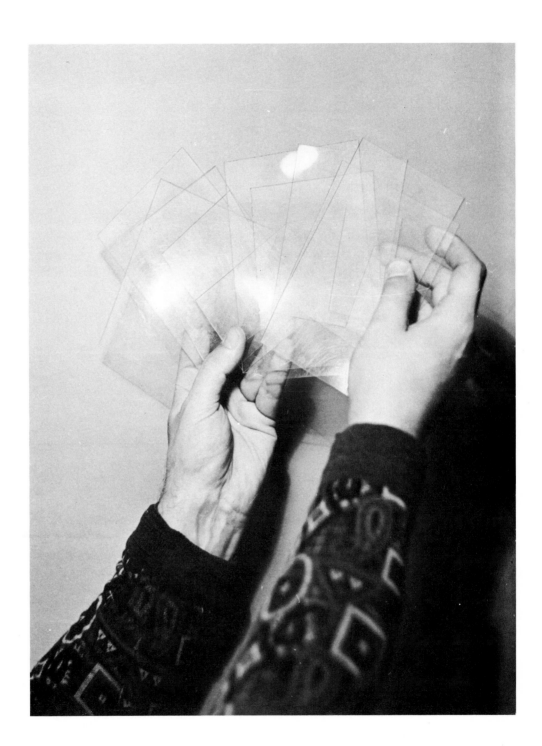

**Documents**                                    1975, photograph

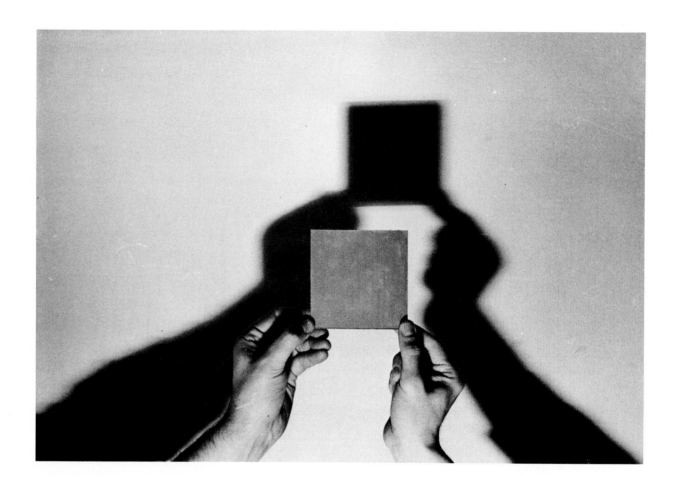

**Documents**

1975, plexiglass, 13 pieces.
Collection of Bob and Maryse Boxer.
Photograph by eeva-inkeri

**Circle, Square, Triangle: Artists' Instructions**

1975, pencil and typewriter on paper, 8″ × 10″.
Photograph by Francis Olschafskie

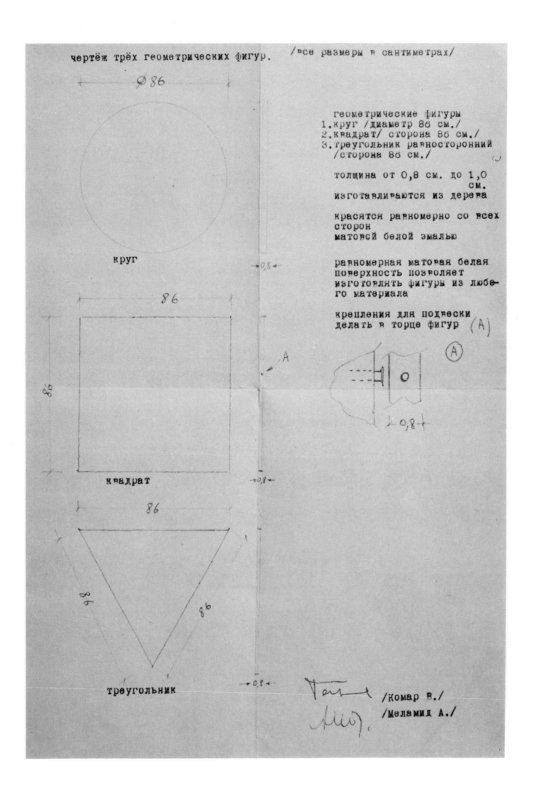

**Circle, Square, Triangle**

1975, wood, triangle and square each side 33½",
diameter of circle 33½", text.
Collection of the artists.
Photograph by eeva-inkeri

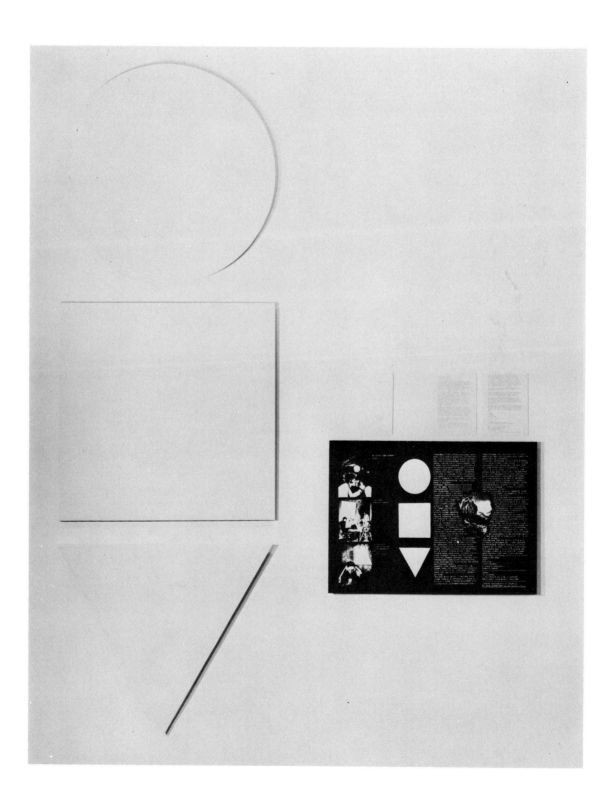

**Color Is a Mighty Power**

1975, oil on wood, with text, each square 1⅝″.
Collection of Bob and Maryse Boxer.
Photograph by eeva-inkeri

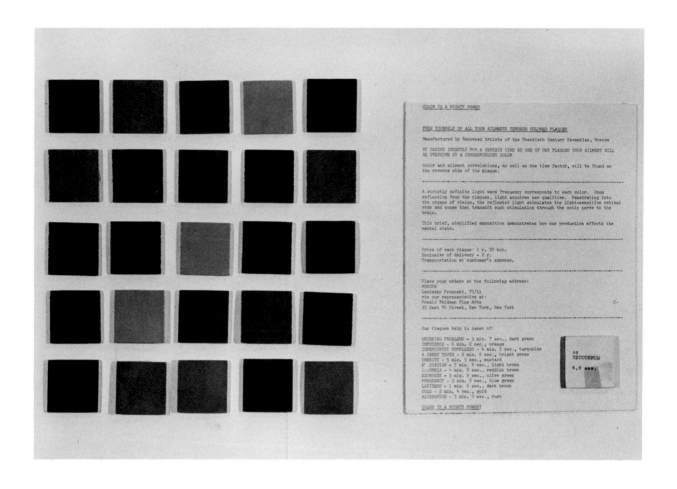

**Glory to Labor**

1975, paint on cloth, 16″ × 78″.
Collection of the artists.
Photograph by eeva-inkeri

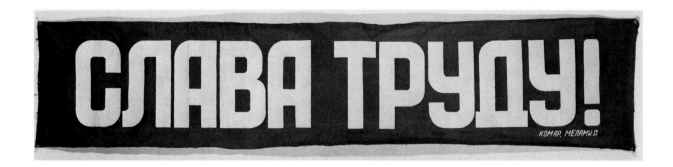

**Scenes from the Future**

(Guggenheim Museum), 1975, paint on masonite panel,
15¾″ by 12″.
Private collection.
Photograph by eeva-inkeri

**Scenes from the Future**

(Kennedy Airport), 1975, paint on masonite panel,
15¾″ × 12″.
Private collection.
Photograph by eeva-inkeri

**Drawings from the Front**

1975, pencil on paper.
Collection of Melvyn B. Nathanson.
Photograph by Francis Olschafskie

**Factory for the Production of Blue Smoke**

1975, oil on 84" × 39".
Collection of Alfred and Pie Friendly.
Photograph by Peggy Jarrell Kaplan

The Renowned Artists
of the End of the 2 Millennium A.D.
Moscow
Leninski Prospect 70/II, Apt. 404
Komar/Melamid

The Prime Minister of Greece
Mr. Karamanlis
Athens

Honorable Mr. Karamanlis!

You are the head of the government of a country which, being the cradle of European civilization, has always evoked the deepest feelings in the heart of every civilized man.

In our century, the problem of preserving harmony between man and the environment is attracting the anxious attention of worldwide public opinion. Who, if not you and your country, could become the pioneers in the matter of resurrecting the idyllic landscape of the long gone Golden Age.

We do not suggest the elimination of the colossal machinery of modern industrial production. However, it is within our power to direct this machinery along the path of eternal and ideal aesthetics. Therefore, we appeal to you, Mr. Prime Minister, and also, in other letters, to the large-scale capitalists of our time, with the request to support the construction of the Factory for the Production of Blue Smoke. We ask you to offer the land of ancient Hellas as an honored site for this factory.

Clean, unpolluted with the ideas of utilitarianism, blue smoke, constantly diffused, will produce monuments to the genuine beauty of human sensibility and intelligence.

We are attaching to this letter a photograph of the design for the Factory for the Production of Blue Smoke.

We hope to receive your reply as soon as possible. Would you please send your reply to our home address: Leninski Prospect 70/II, Apt. 404, Moscow, USSR, or to the Ronald Feldman Gallery, 33 East 74th Street, New York, New York 10021.

The coordination of organizations which are financing the project and the purchase of the land is to be handled through the Ronald Feldman Gallery.

**Questions New York Moscow New York Moscow**     1976, Komar/Melamid with Douglas Davis, photo blowup, 30″ × 40″

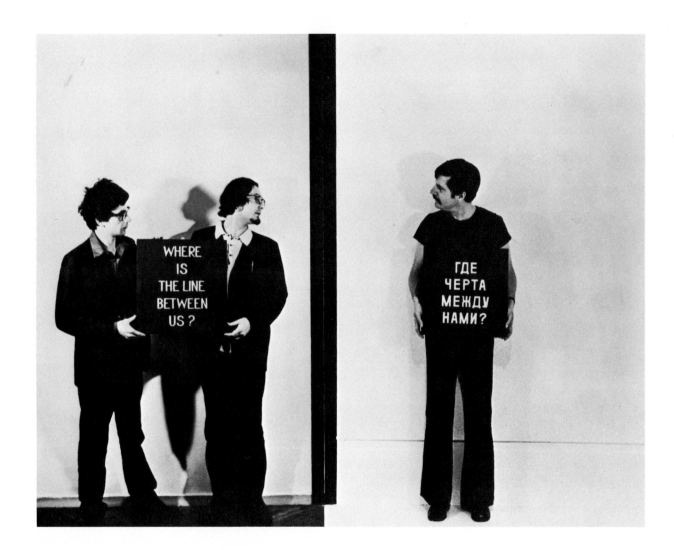

**Scroll**

1975, oil on canvas.
Collection of the Grinstein Family.
Photograph by eeva-inkeri

**History of the USSR**

1976, oil on canvas, 58 panels, each panel 31½″ × 12″, panels 46–50 (1962–66).
Collection of Mr. and Mrs. Goldberger, San Juan, Puerto Rico.
Photograph by Peggy Jarrell Kaplan

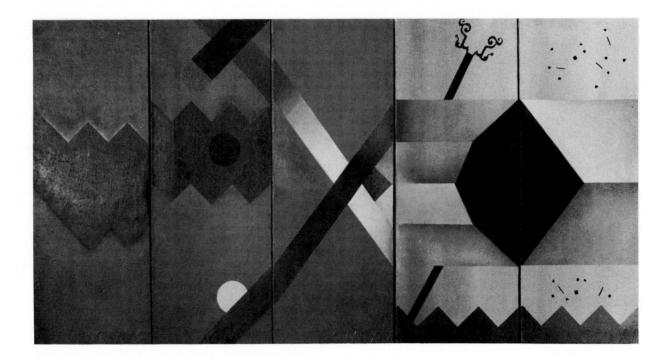

**History of the USSR**

1976, panels 51–55 (1967–71).
Collection of Mr. and Mrs. Goldberger, San Juan,
Puerto Rico.
Photograph by Peggy Jarrell Kaplan

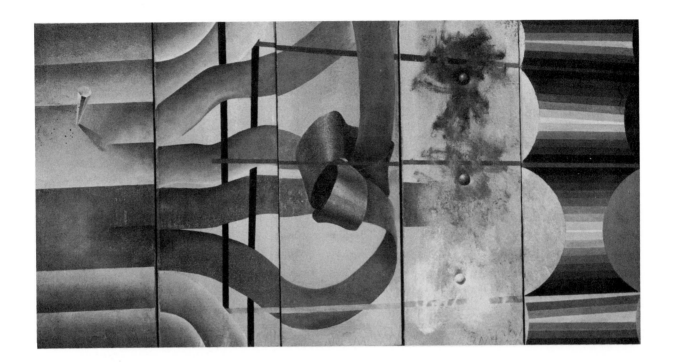

**History of the USSR**

1976, panels 56–58 (1972–74).
Collection of Mr. and Mrs. Goldberger, San Juan,
Puerto Rico.
Photograph by Peggy Jarrell Kaplan

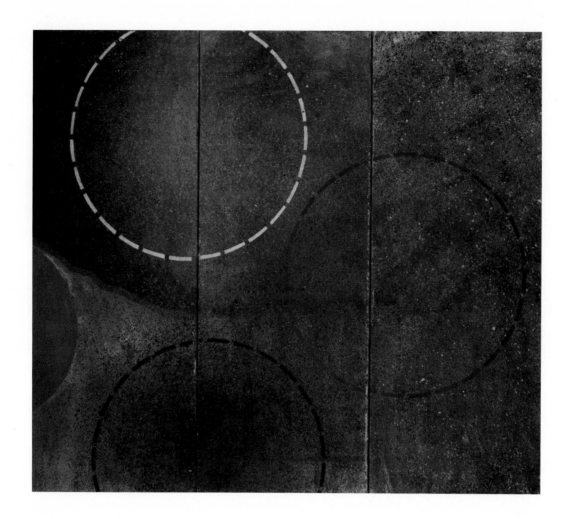

**Cut-Off Corner Series, Chemical Reaction**

1975–76, mixed media on canvas 39½″ × 51″.
Collection of the artists.
Photograph by Peggy Jarrell Kaplan

**Cut-Off Corner Series, Not Yet Too Late**

1975–76, acrylic on linen, 39" × 35".
Collection of Mr. and Mrs. Ira Weinstein.
Photograph by Peggy Jarrell Kaplan

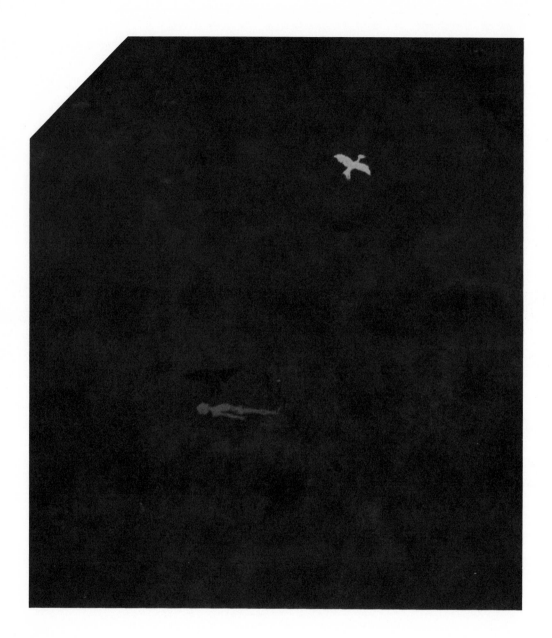

**Cut-Off Corner Series, KGB**

1975–76, acrylic on canvas, 47″ × 31″.
Private collection.
Photograph by Peggy Jarrell Kaplan

**Cut-Off Corner Series, Reproduction from a
Picture on a Subject from Russian History**

1975–76, oil on paper, 6½″ × 8½″.
Collection of the artists.
Photograph by Peggy Jarrell Kaplan

**Prophet Obadiah**

1976.
Collection of the artists.
Photograph by eeva-inkeri

**Installation**

Ronald Feldman Gallery, May 1977,
on rear wall is *Farewell to Russia*.
Photograph by Peggy Jarrell Kaplan

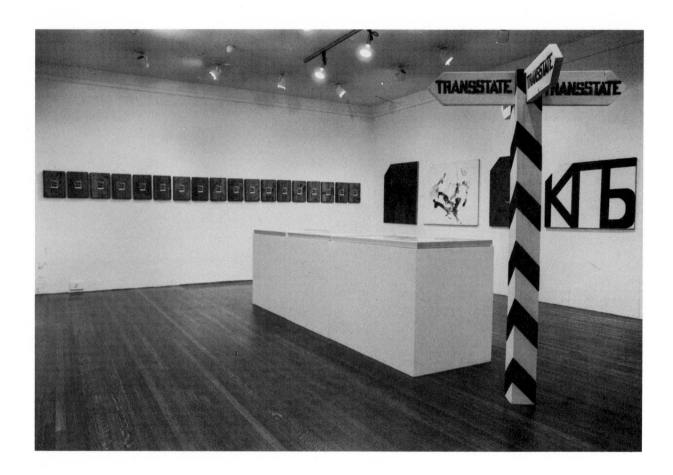

## ПРОЩАНИЕ С РОССИЕЙ

Навостри топор,
размахнись рука—
топором руби—
в сердуецину меть—
ты воткнись игла,
глаз и пуп пронзи,
чтобы вышел дух
из дыры насквозь—
в суть и корень меть—
деревам, домам,
кораблям, плодам,
злакам и полям
и всему что есть,—
что растёт, стоит,
что живёт—даёт

## Farewell to Russia

Get the axe ready,
Swing your arms—
Slash with the axe—
Take aim at the core—
You drive in the needle,
Pierce the eye and the navel,
And the spirit flies out
From the hole throughout—
Take aim at the essence and the root—
For the trees, the homes,
For the ships, the fruits,
For the grains and the fields
And for everything there is,—
That grows, stands,
That lives, allows

жить России всей,—
отомсти Руси
за жида, за кровь,
разруби её,
уничтожь её,
остр кол воткни
в плоть и кровь её,
пригвозди язык,
чтоб на сеи земле
слову не звучать,
деревам не быть—
гнить стволам в земле,
листьям не шуметь,
тени не давать,
хлебу не расти,
быть пенькам одним
и пенькам не быть,
чтобы камню—в прах,
чтоб железу—течь,
что горит,—то в дым,
что течёт,—то в пар,
а живому здесь,
кто ещё не сбёг—
в глаз и тело бей—
мясо червь пожрёт,
станет червь жирён,
чтоб он всё пожрал
и сожрав, подох,—
сыпь отравныи дуст
в реки и моря,
чтобы рыба—вверх,
а людишки вниз,
чтоб на сей земле
от воды всем смерть,
от земли всем смерть,
и от ветра смерть,
и от камня смерть,
от железа смерть,
от живего смерть
и от смерти смерть,
смерть России, смерть,
чтоб на сей земле
никому не жить
и земле не быть,
ничему не быть,
никому . . .
ничему . . .

All of Russia to live,—
Avenge Rus'
For the Yid, for the blood,
Cut her into pieces,
Destroy her,
Drive a sharp stake
Into her flesh and blood,
Nail down her tongue,
So that on this earth
A word will not be heard,
There will be no trees—
Their trunks rotting in the ground,
The leaves will not sound,
Nor make shadows,
Grain will not grow,
There will be only hemp
And there will be no hemp,
And the stone turns to dust,
And the iron flows,
That which burns will turn to smoke,
That which flows—to steam,
And the living here
Who has not yet run off,
Beat him in the eye and body—
The worm will chew the meat,
The worm will become fat,
Because he has consumed everything,
And, having consumed it, dropped dead.
Sprinkle poison dust
In the rivers and seas,
And the fish will be above
And the people below,
And on this earth
There will be death for all from the water,
And death for all from the land,
And death from the wind,
And death from the stone,
Death from iron,
Death from the living
And death from death,
The death of Russia, death,
And on this earth
No one will live
And there will be no earth,
There will be nothing,
No one,
Nothing . . .

OLO

A Language Ornament!

Your every word is gold, your every word—a pearl!

OLO is proof of your ideal marriage with Truth!

**A Catalog of Superobjects—
Supercomfort for Superpeople**

1976. This work is in an edition of one hundred copies
and consists of thirty-six 8″ × 10″ color photographs
and text

KHAASHA

For a Healthy Body—a Healthy Spirit!

A sniffing apparatus for the head, KHAASHA-200 will replace the anxious odors of the world with the single, stable scent of your desire!

This elegant piece of jewelry made of gold or silver holds the source of the smell you want to smell.

Just fill this special, medium-size chalice with a small piece of your love's skin or hair, flower petals, or whatever you prefer—by inclination and conviction.

A Catalog of Superobjects                    photograph

UDAM

Take UDAM and Listen to Yourself!

UDAM-II, the Auto-Auditor, is made of natural rubber with gold-plated points.

Helps you concentrate on yourself and brings out your CREATIVE POTENTIAL.

The special, soft padding for the ear contacts completely, which halts penetration by extraneous noise.

Before work . . .
Before every important decision . . .

Listen to yourself with the help of UDAM!

**A Catalog of Superobjects**                    photograph

KHUDAM

Take KHUDAM and smell yourself!

The smells of the world block out your own smell!

Smell yourself!

KHUDAM-212, the Self-Scenter, is made of natural rubber with gold-plated points. Helps you concentrate on yourself and brings out your SPIRITUAL POTEN-TIAL.

The special soft padding of the point completely halts penetration by extraneous smells.

Before work . . .
Before every important decision . . .

Smell yourself with the help of KHUDAM!

**A Catalog of Superobjects**          photograph

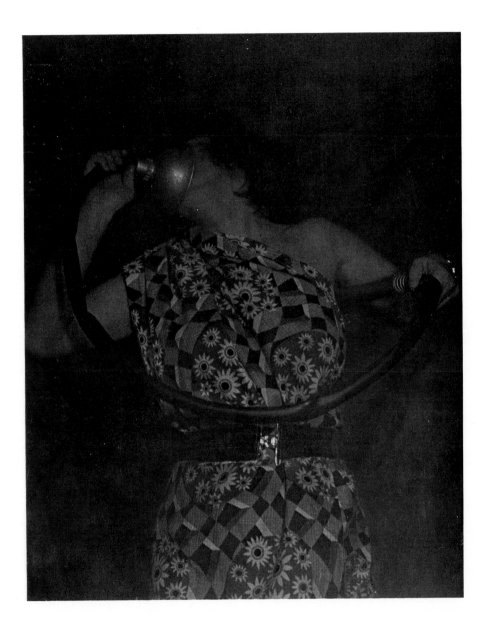

**Young Marx**

1976, oil on dishrag, 32″ × 24″.
Private collection

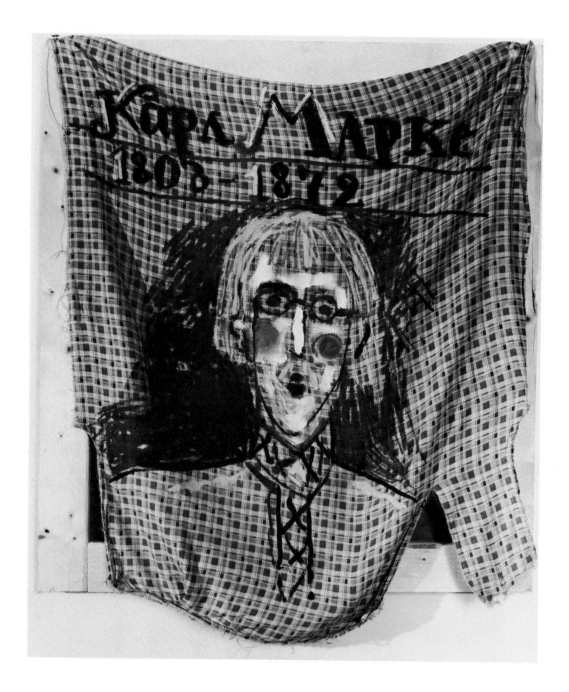

**Installation**

Ronald Feldman Gallery, May 1977, on the rear wall is the *Catalog of Superobjects*, in the display cases is *TransState*.
Photograph by Peggy Jarrell Kaplan

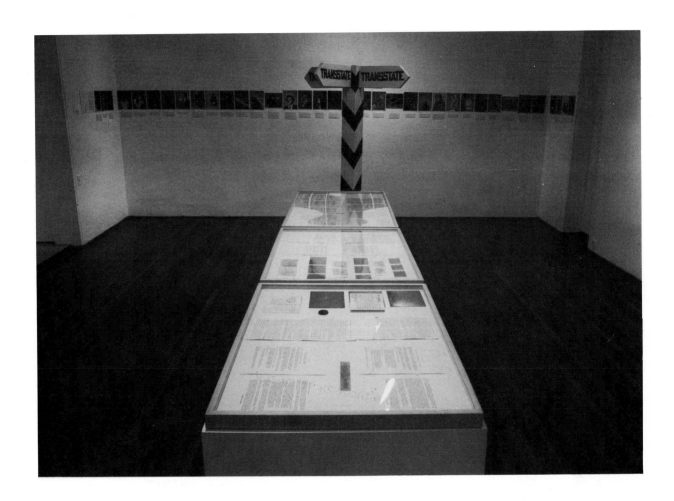

**Passport** from **TransState**

1977, documents.
Collection of the Grinstein Family.
Photograph by eeva-inkeri

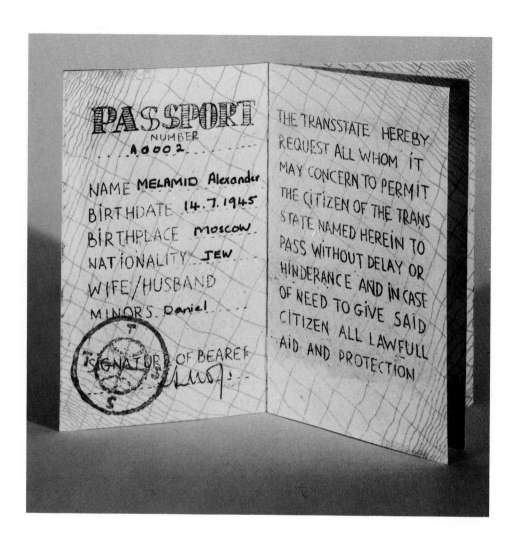

# The Temple of Komar and Melamid

On 27 April 1978, Komar and Melamid organized a happening in Jerusalem on a hillside overlooking Gehenna, a place regarded as Hell in Jewish folklore. The carried up the hill a large aluminum triangular "temple" with a red star on top. On an altar inside the temple they placed the Soviet suitcase that Komar had brought from Moscow when he emigrated in December 1977. A crowd watched, and a young Russian boy played a trombone as Komar and Melamid set fire to the suitcase. After this "sacrifice," they displayed a scroll describing in thirteen verses of biblical Hebrew their exodus from Russia and passage to Israel. This is the *Book of Komar and Melamid*, which they have added to the Old Testament as the final volume of the Prophets. Komar and Melamid distributed oranges to the onlookers. Then they destroyed their temple, and the happening was over.

This event was the basis of a new work by Komar and Melamid, *The Testament of the Priest and the Teacher*, 1978, which was shown at the Ronald Feldman Gallery in New York in an exhibit that opened on 5 October 1978. (In Hebrew, *komar* means "priest" and *melamid* means "teacher.") The work consists of the *Book of Komar and Melamid* (in a limited edition), the *Icons*, three painted wooden triangles for each of the thirteen verses of the *Book*, and the *Artifacts*, thirteen sets of objects associated with the verses of the *Book*. For example, one of the artifacts is Melamid's original Soviet exit visa. Another artifact consists of remnants of the destroyed temple.

The photographs on the following pages document the construction and destruction of the Temple of Komar and Melamid in Jerusalem. Media Contemporary Arts, Ltd., supplied the photographs.

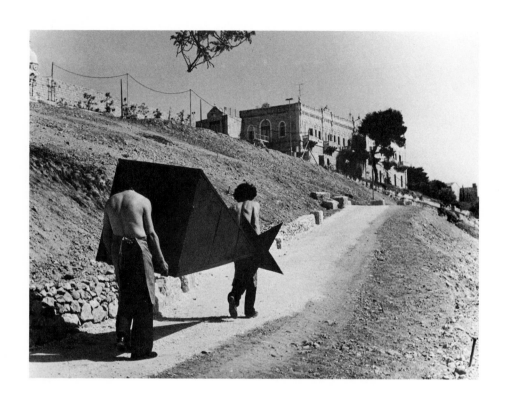

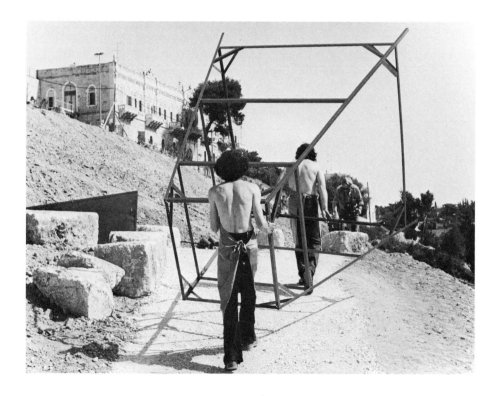

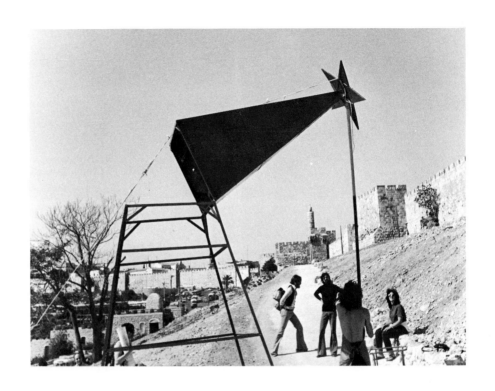

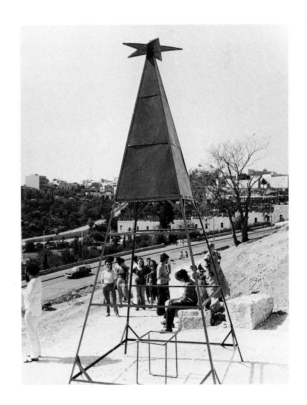

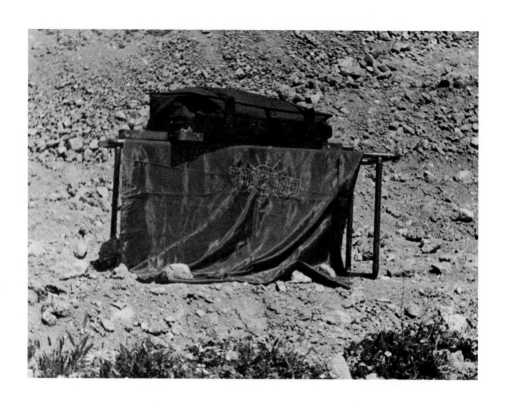

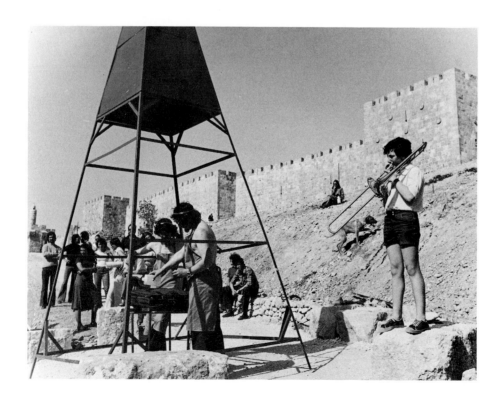

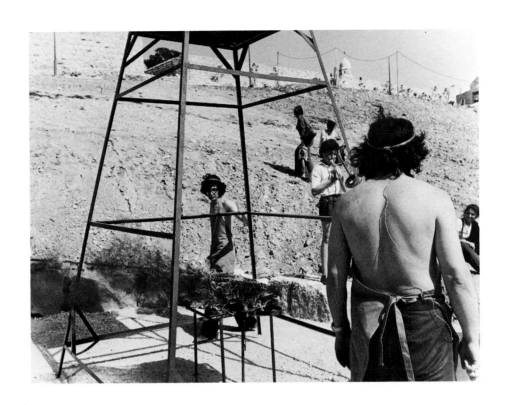

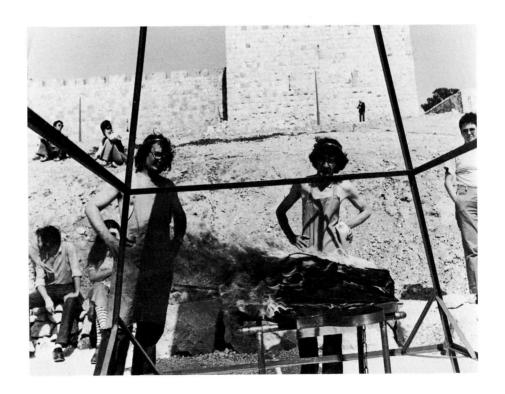

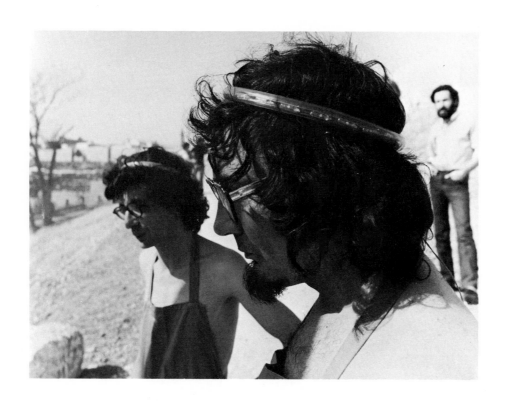

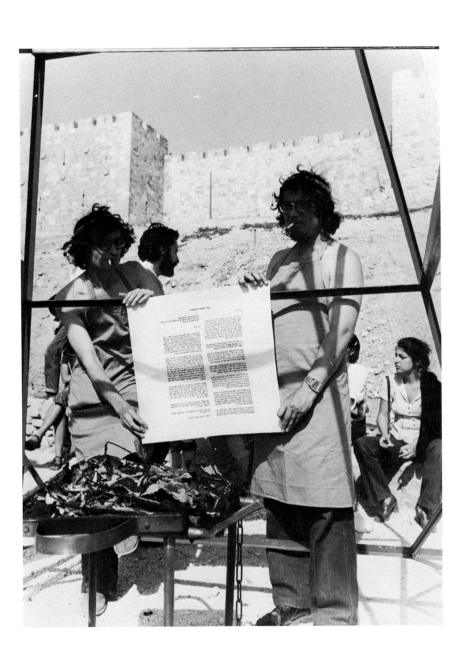